GW00587515

# MIES REFLECTIONS

TRIANGLE ▼ POSTALS

mies☐☐☐▬barcelona

# REFLECTIONS

# MIES VAN DER ROHE PAVILION

photography: **LLUÍS CASALS**

text: **JOSEP M. ROVIRA**

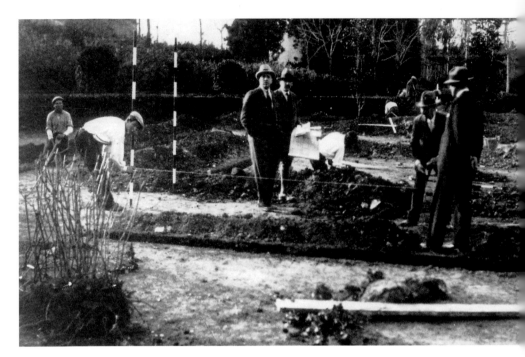

Mies van der Rohe in a photograph taken
during work on the German Pavilion for the
International Exhibition of Barcelona
of 1929, (March-May, 1929).

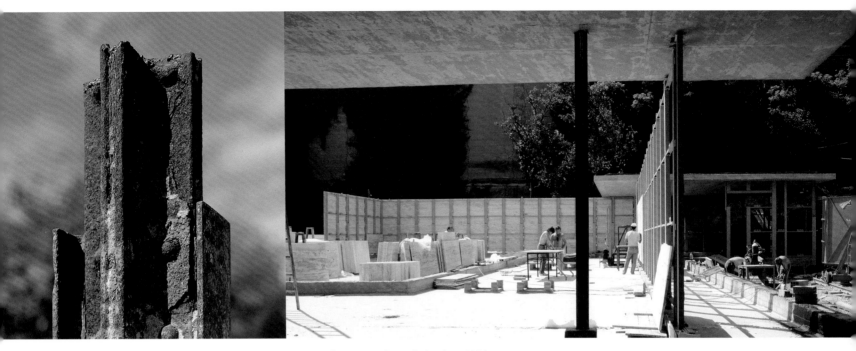

Fragment of a metallic pillar from the original construction found in the basement during the reconstruction work (1983-1986).

The Pavilion was demolished in 1930. After decades of neglect, Barcelona City Council began its reconstruction, a project entrusted to the architectural team of Cristian Cirici, Fernando Ramos and Ignasi Solà-Morales.

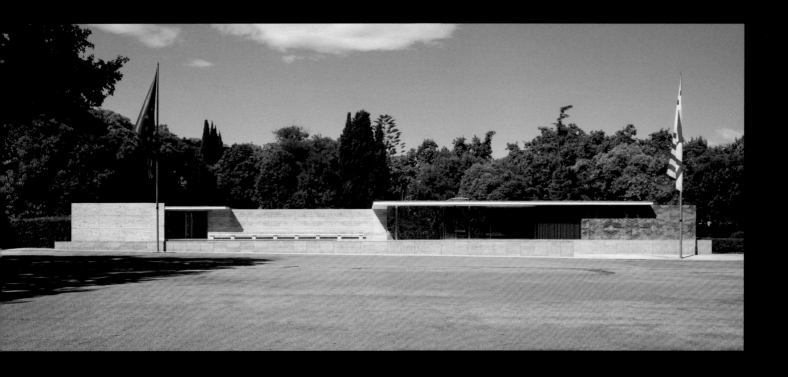

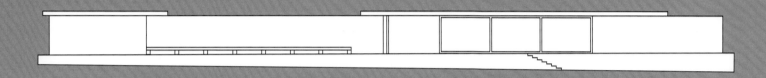

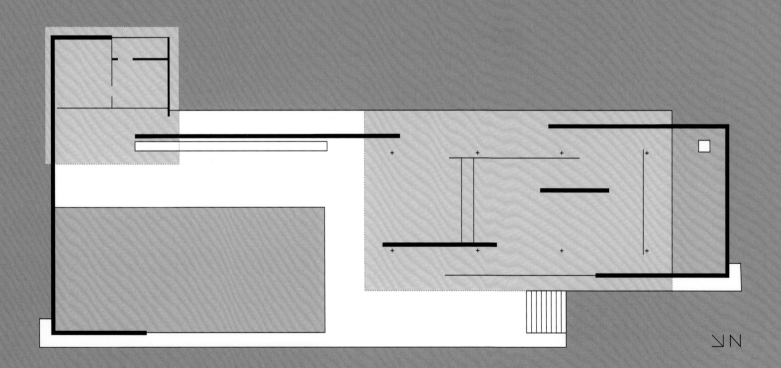

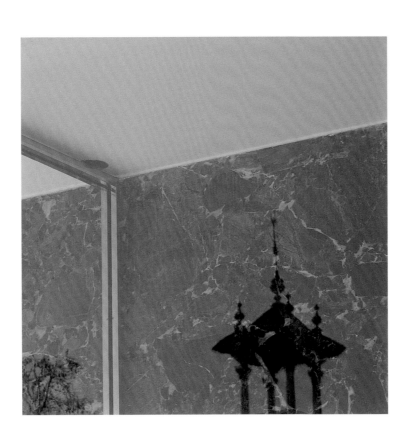

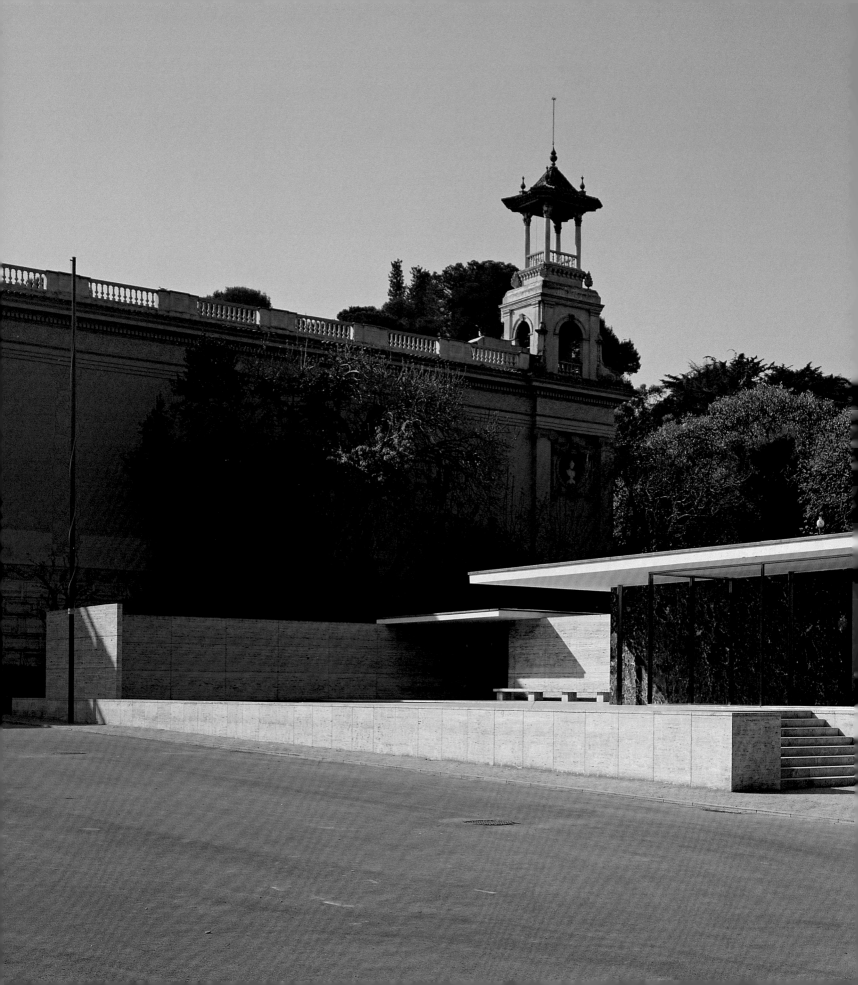

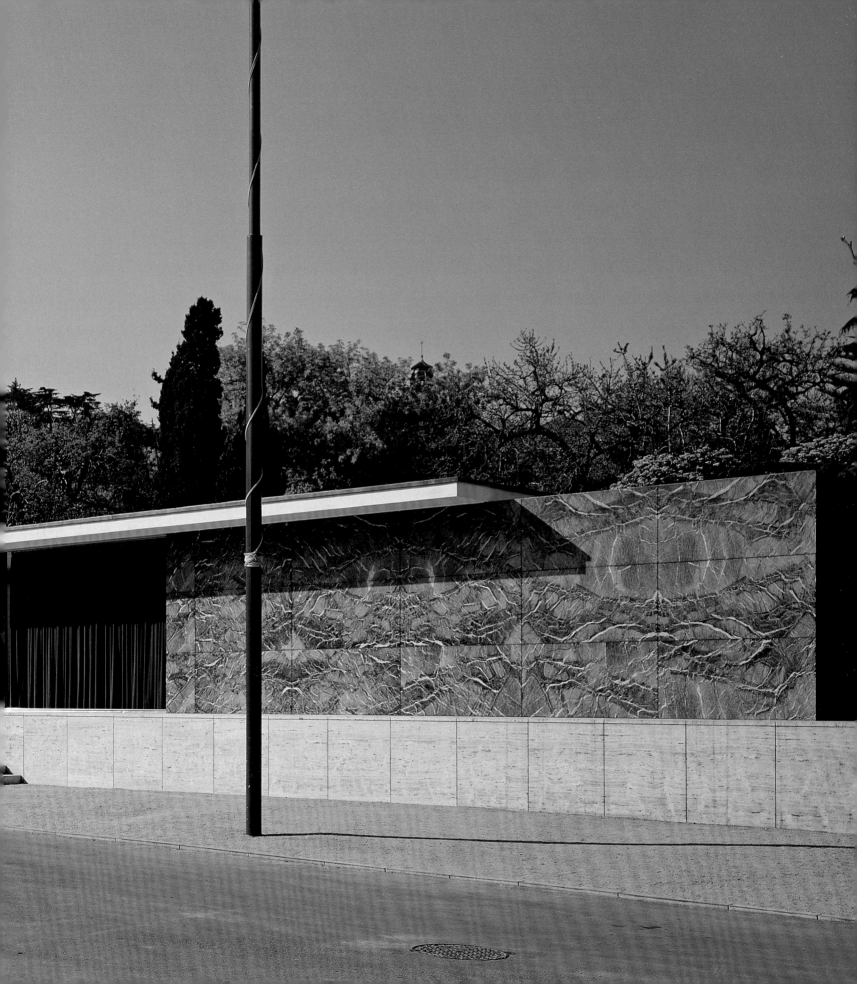

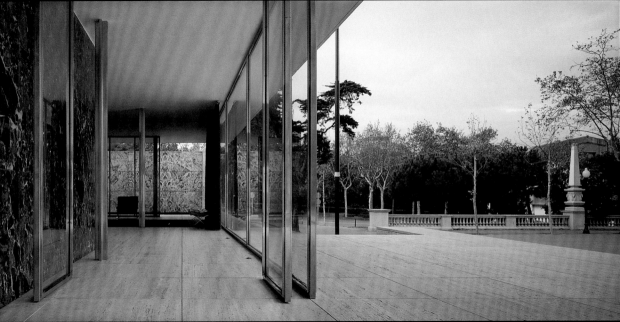

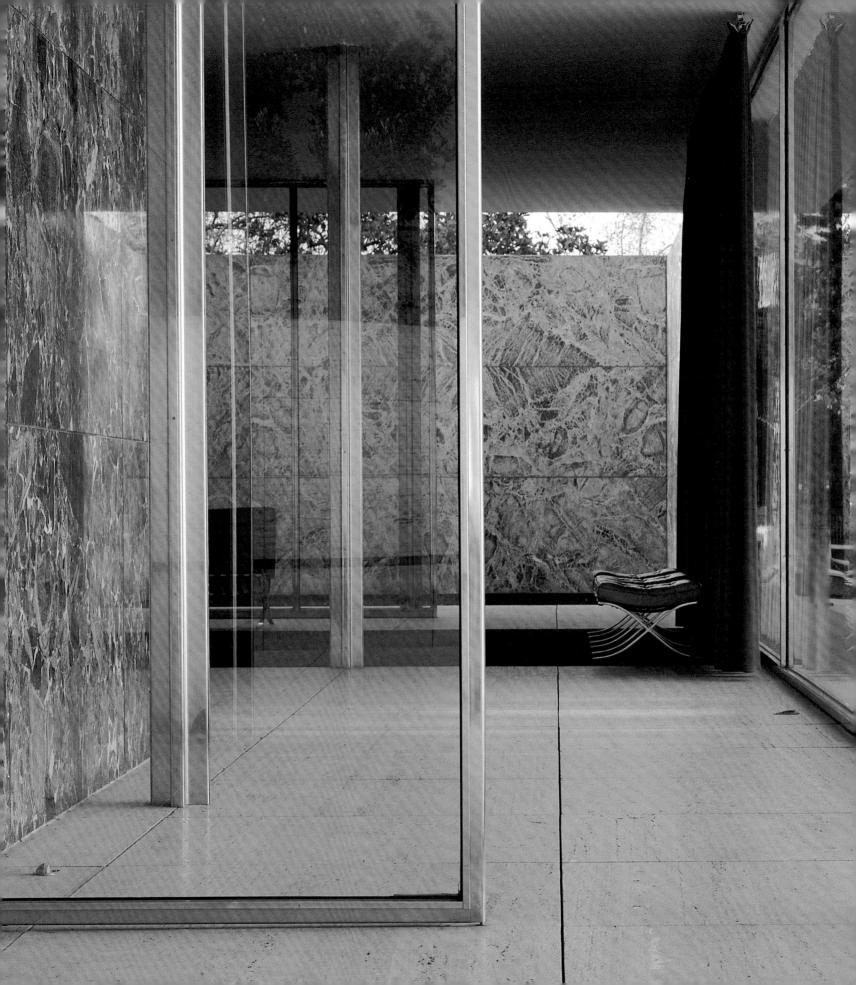

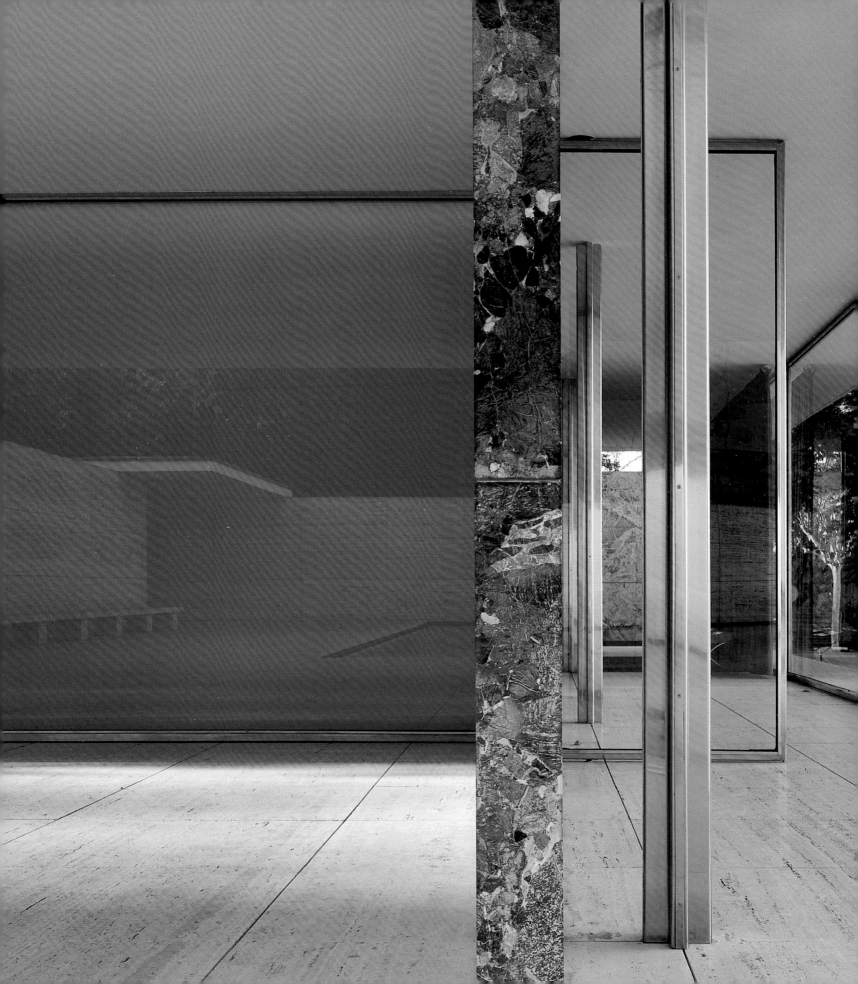

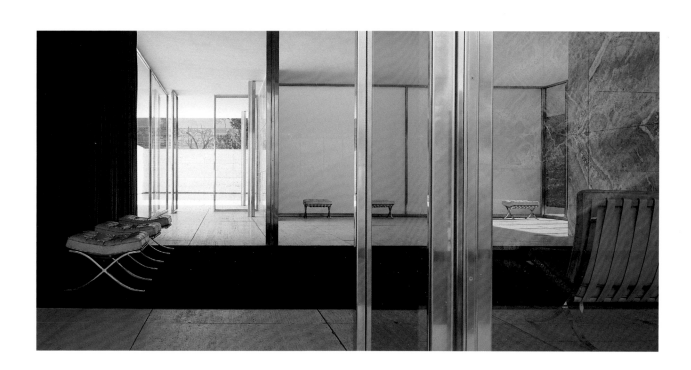

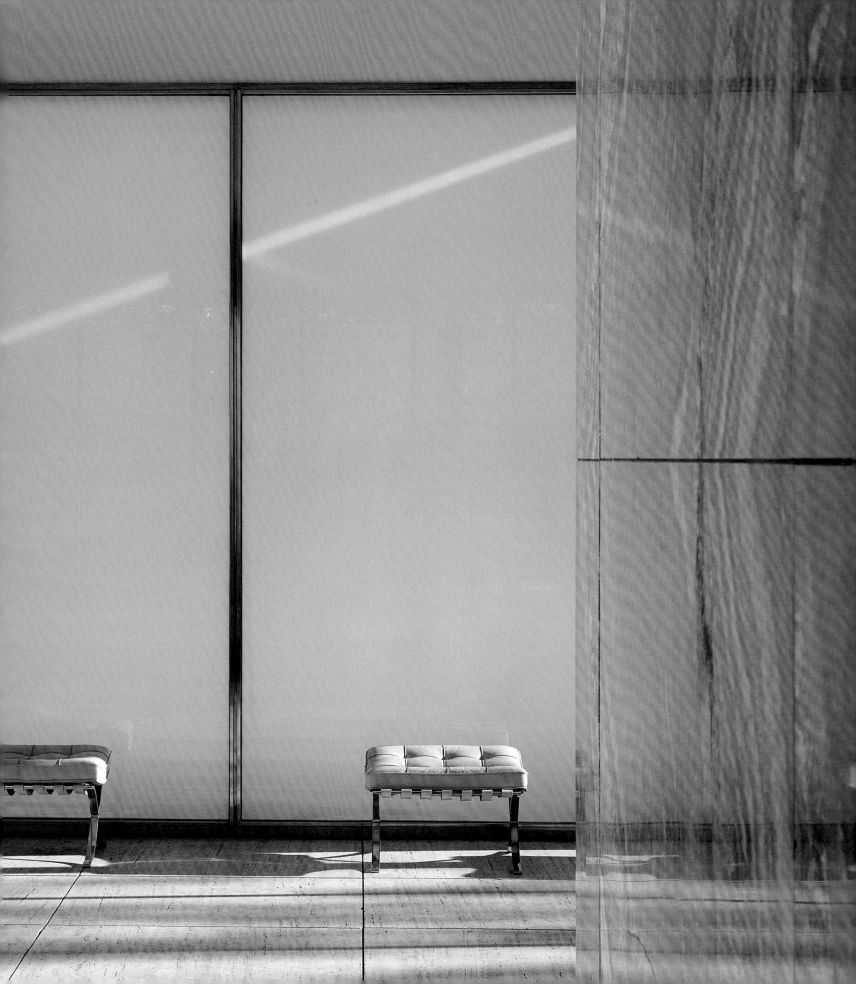

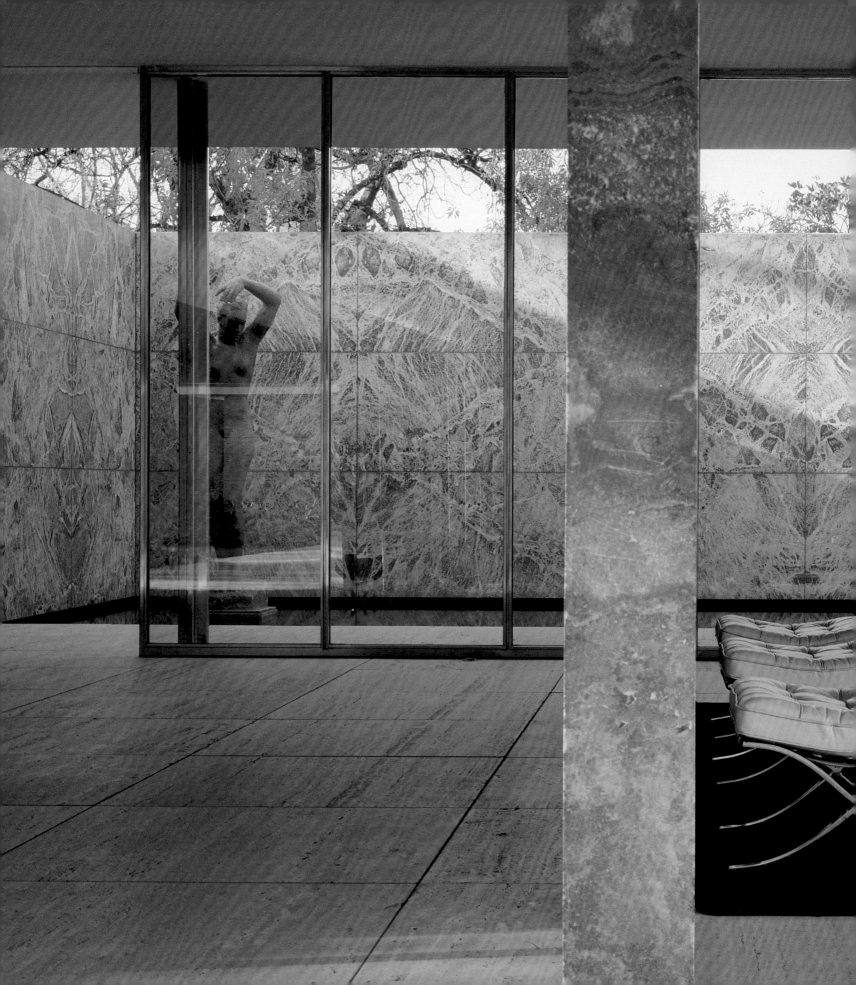

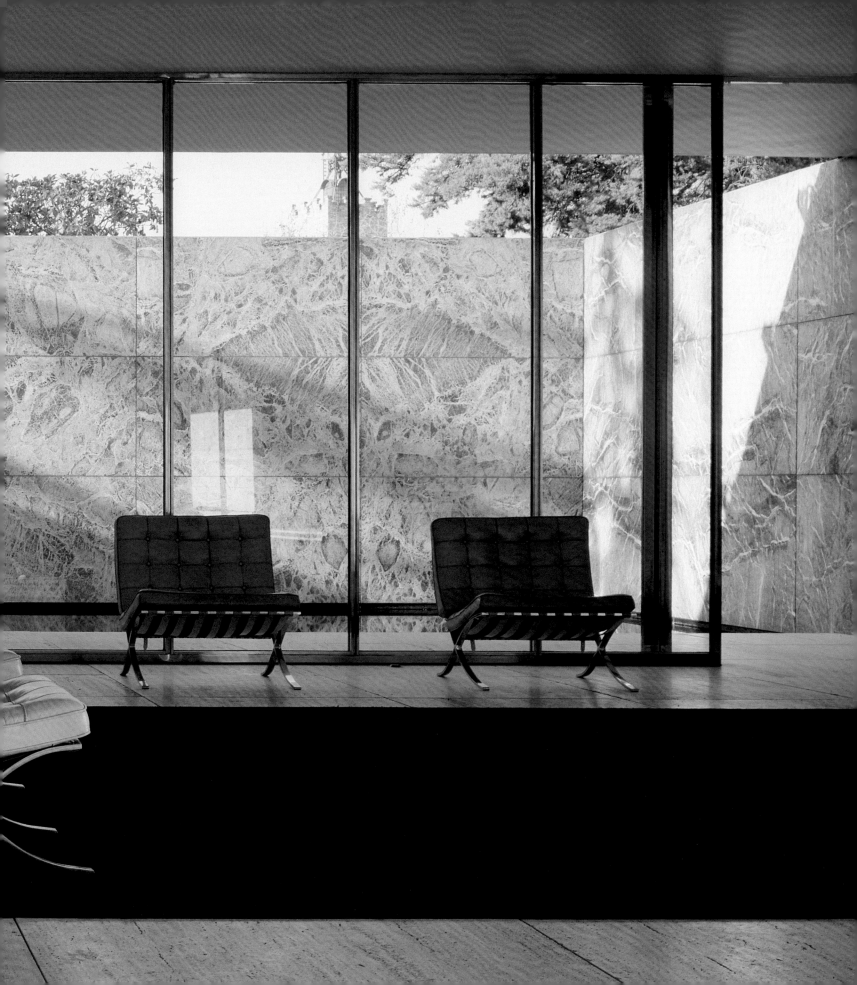

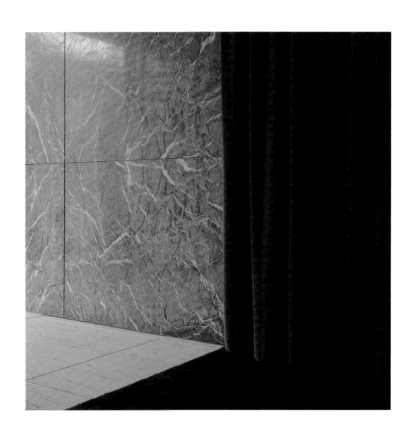

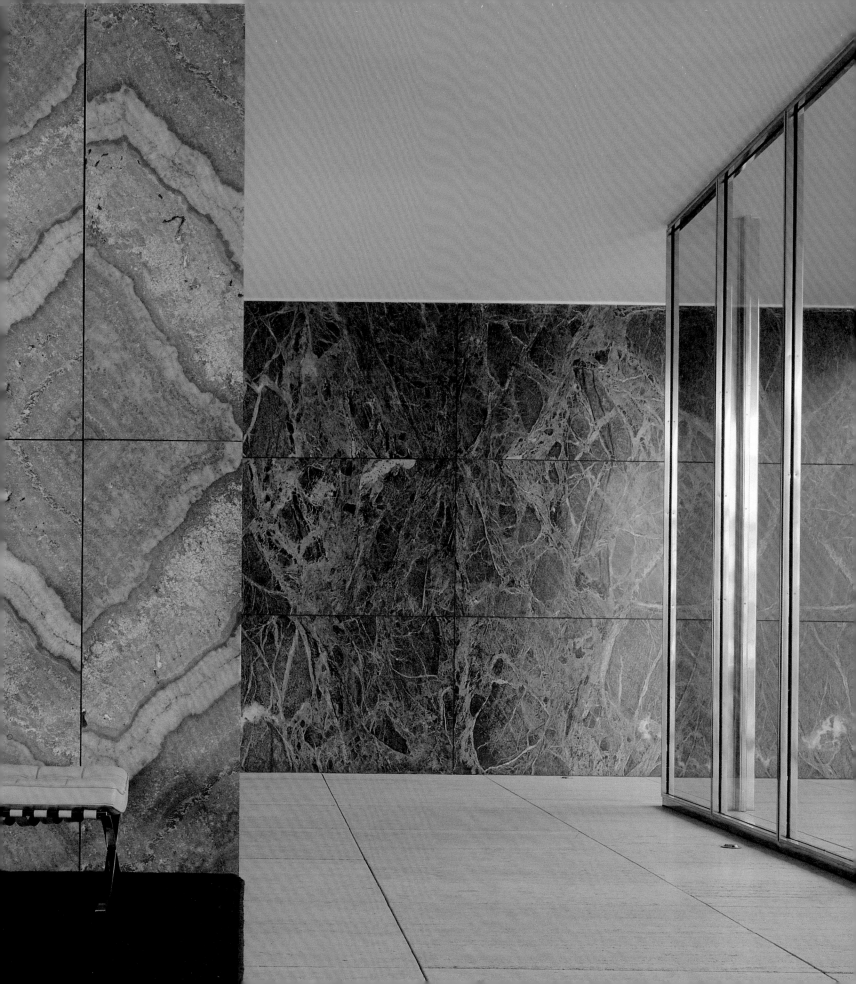

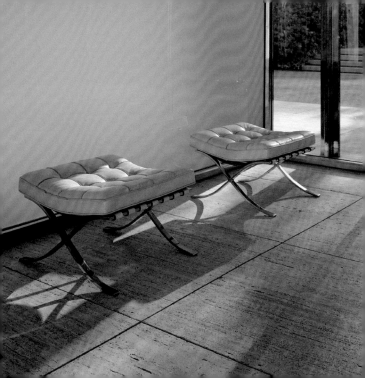

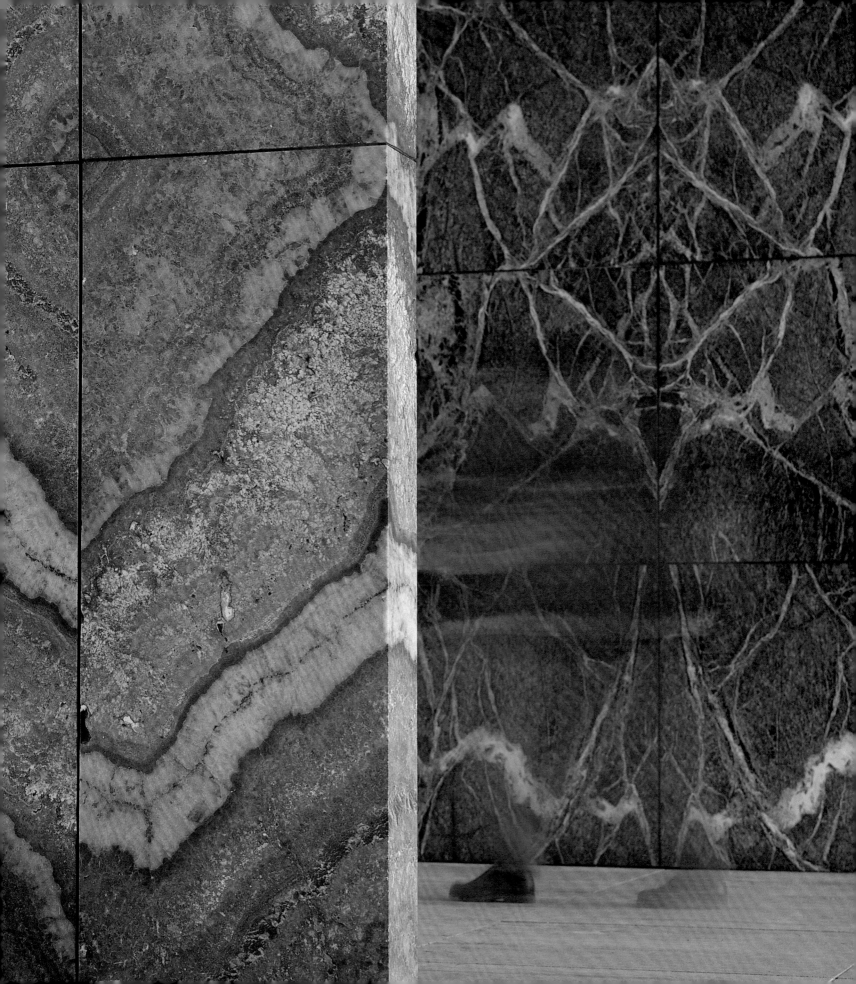

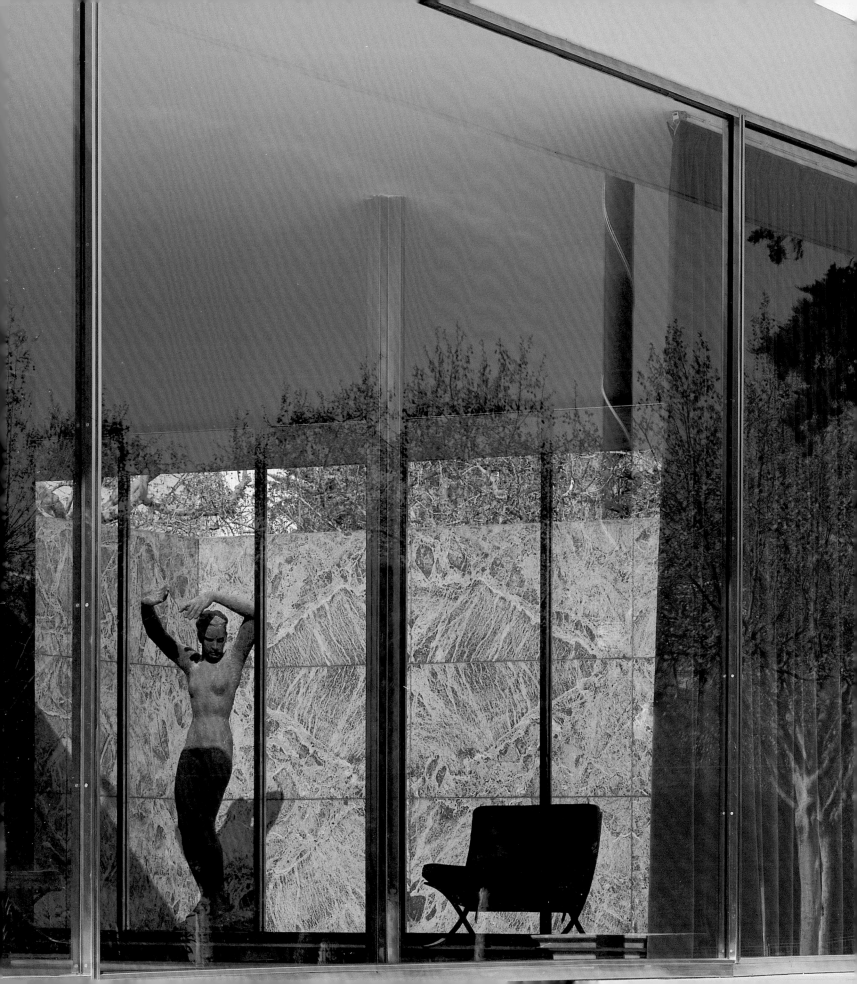

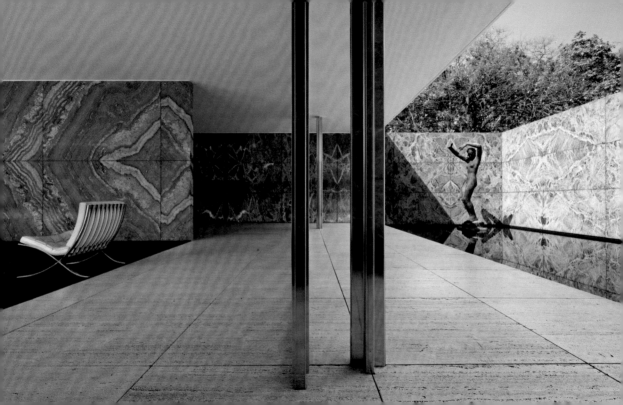

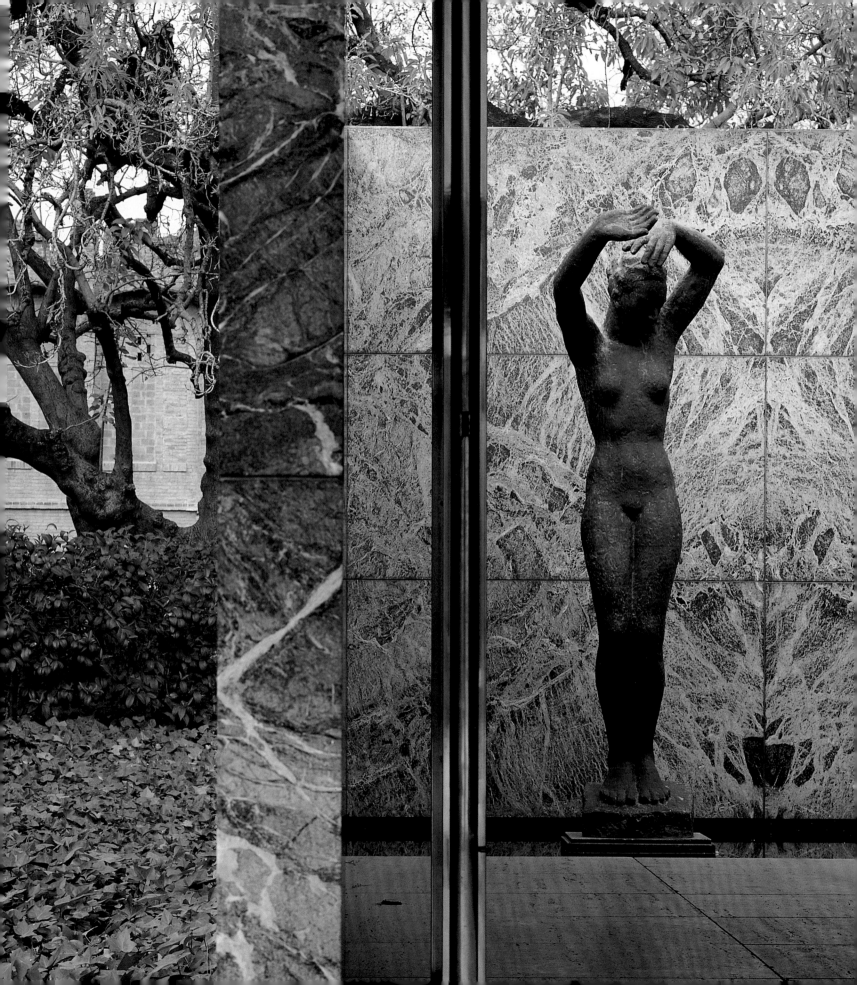

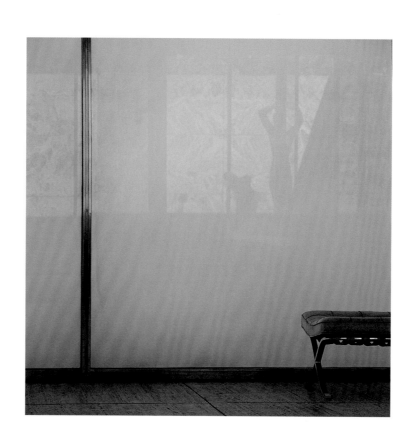

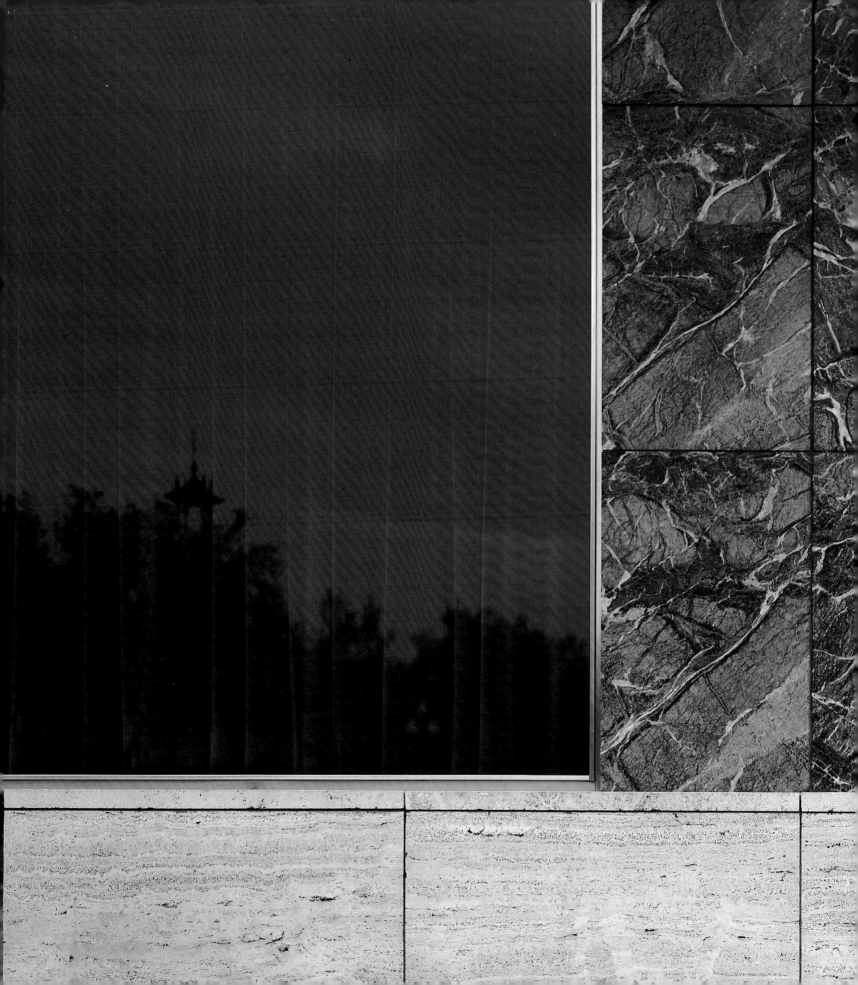

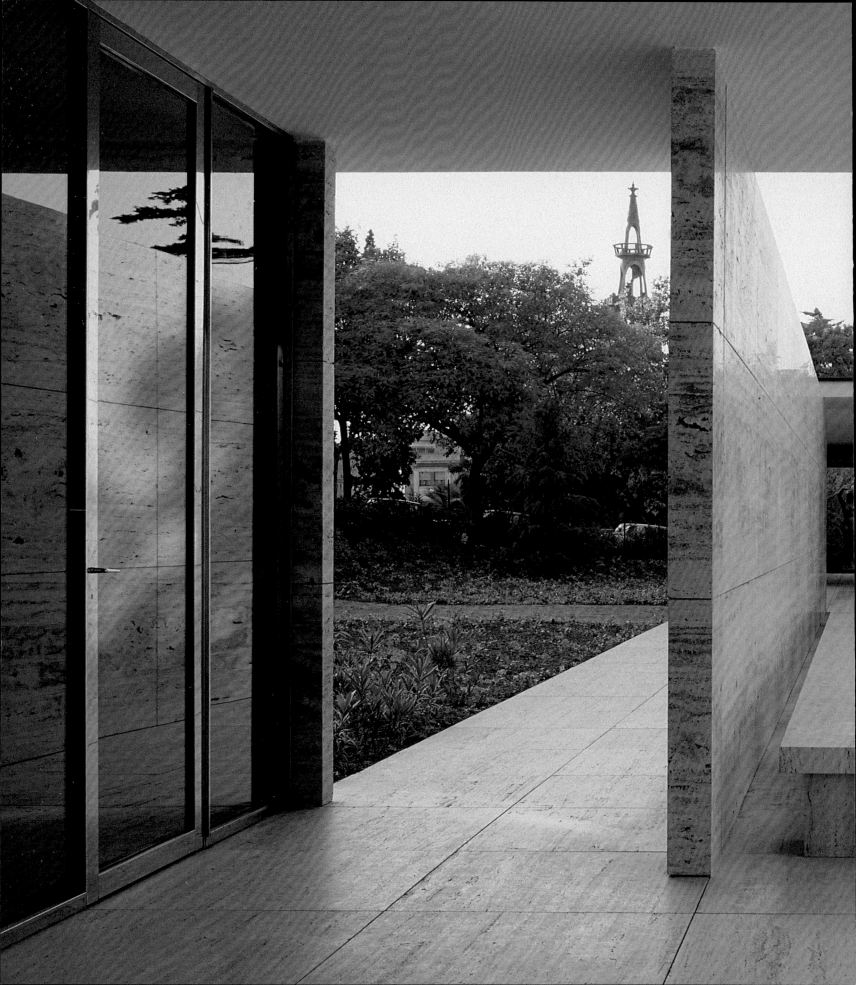

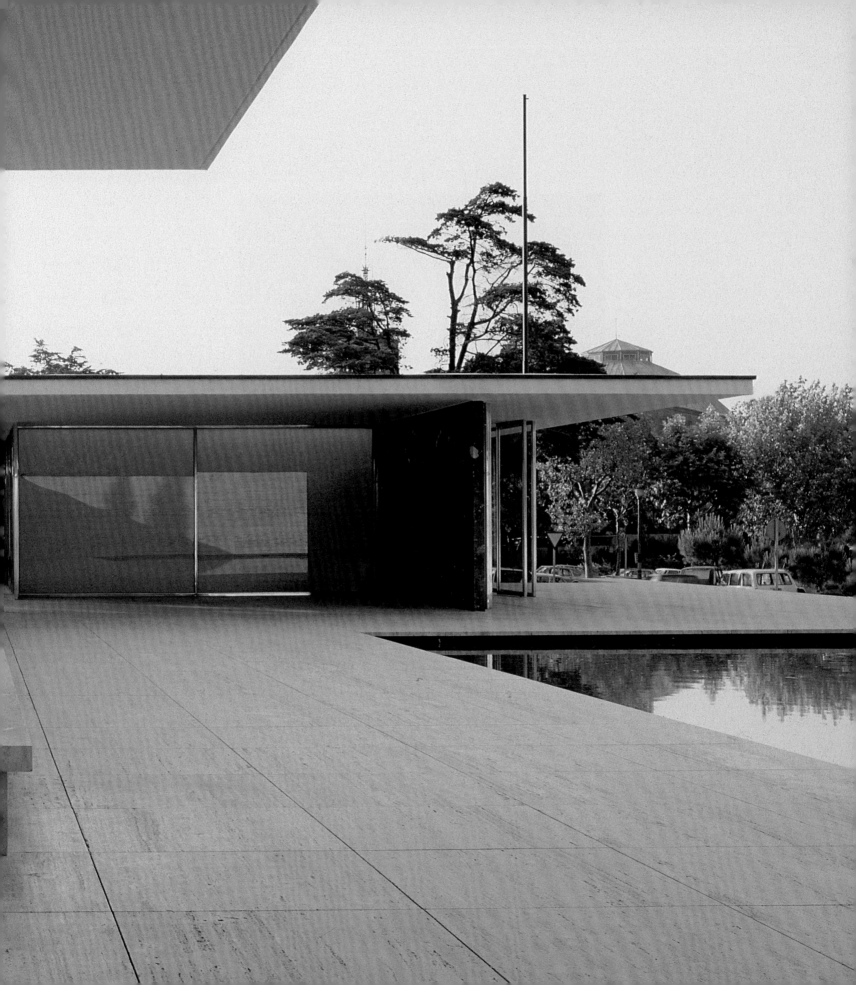

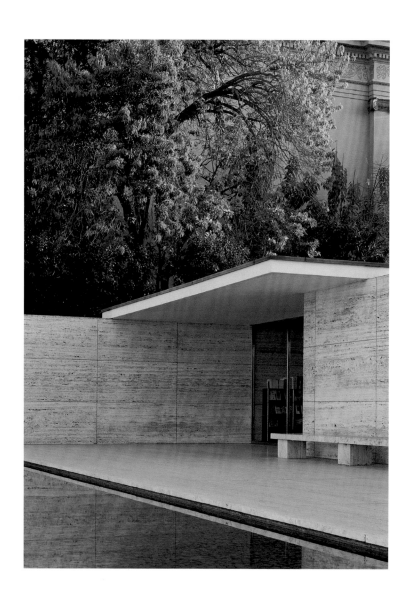

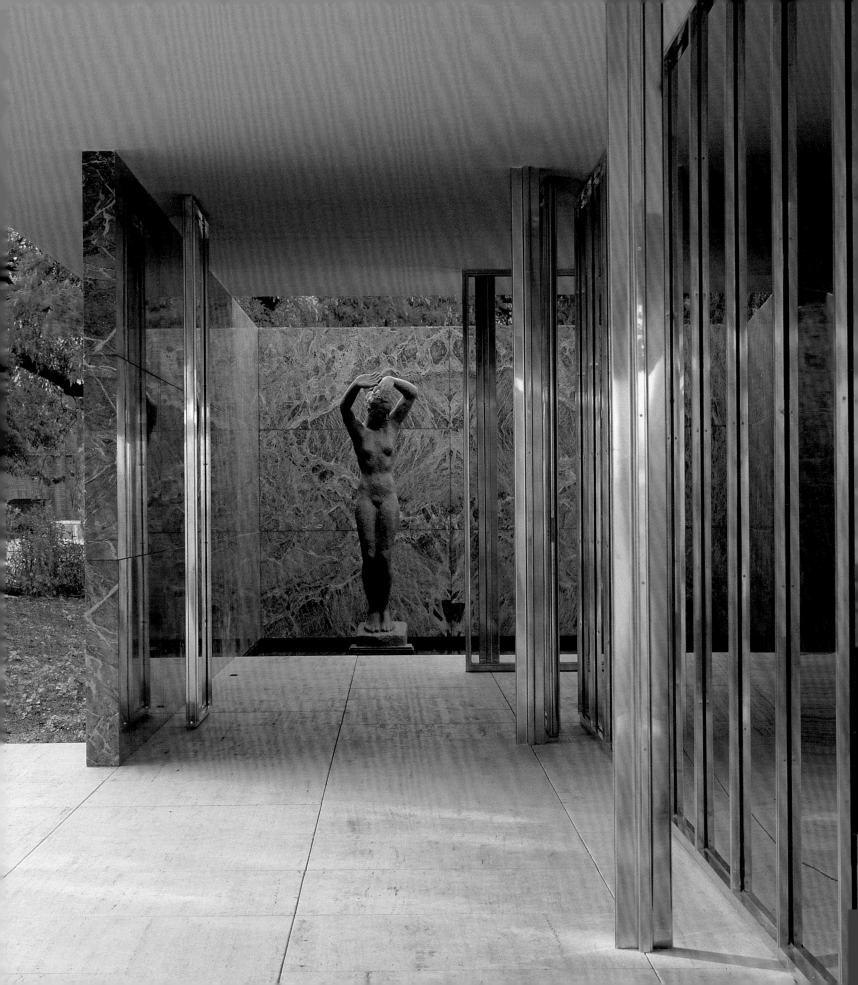

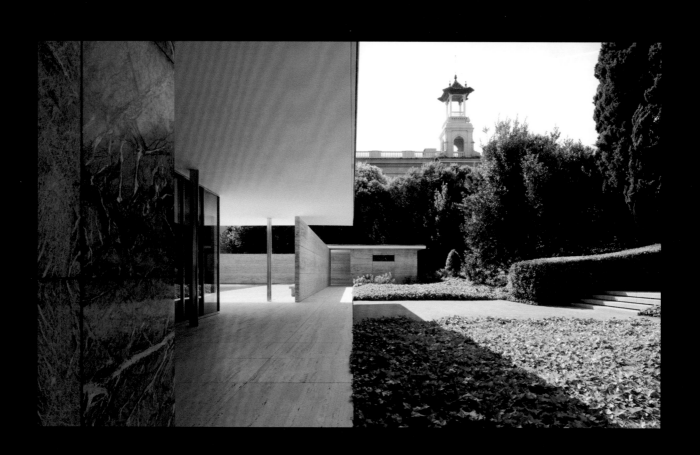

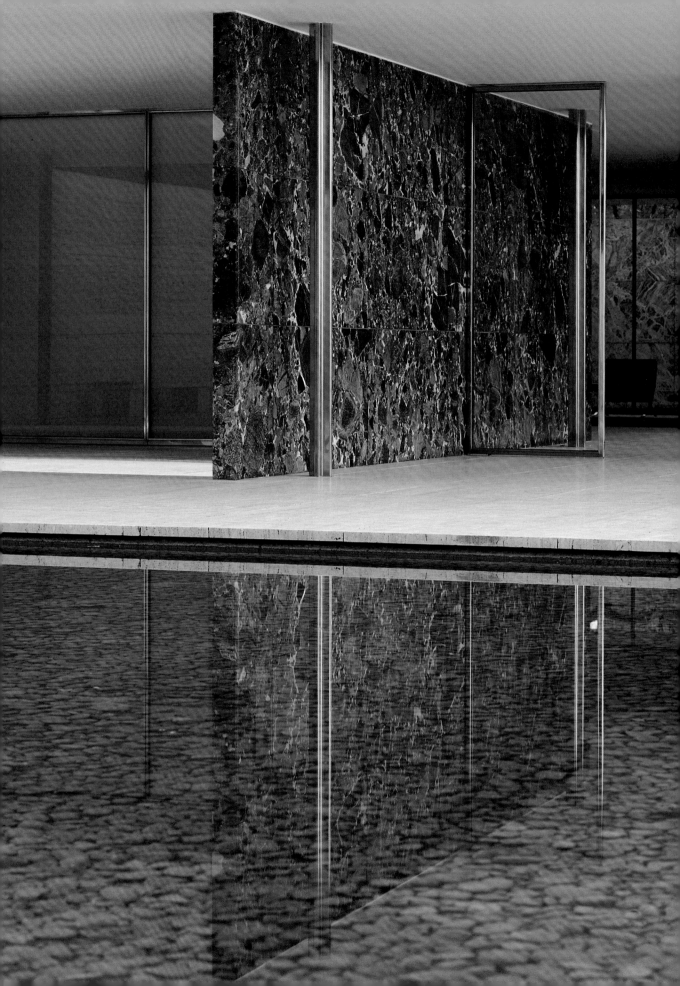

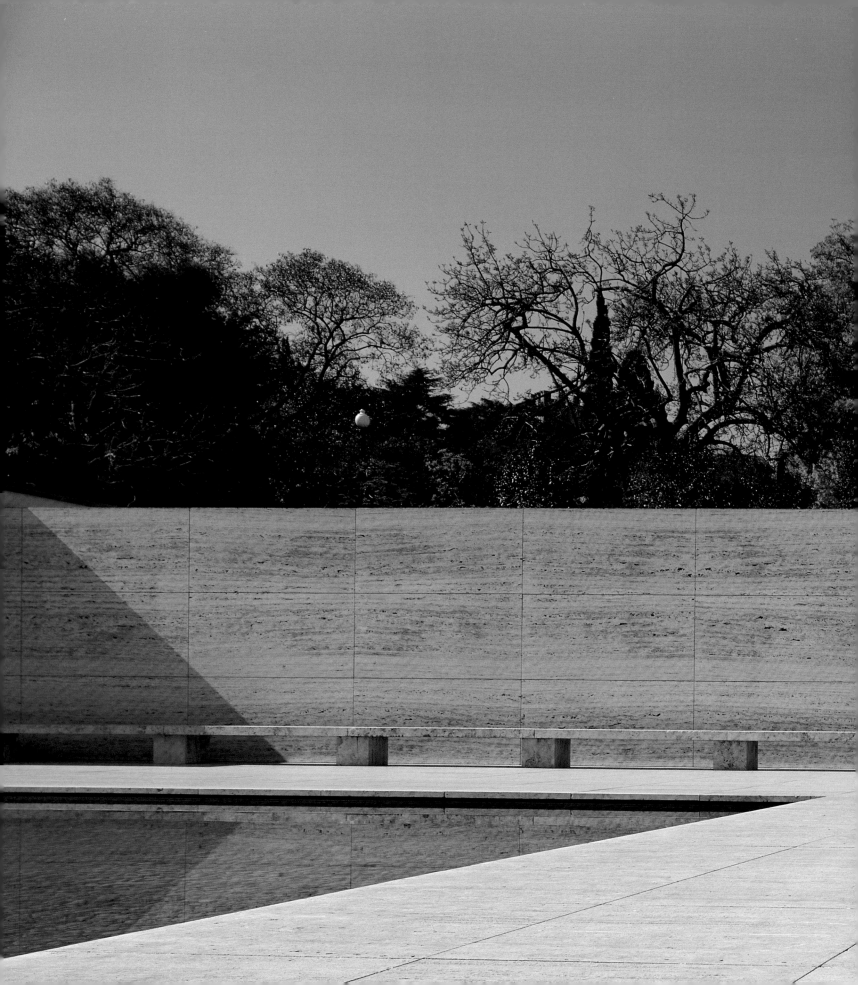

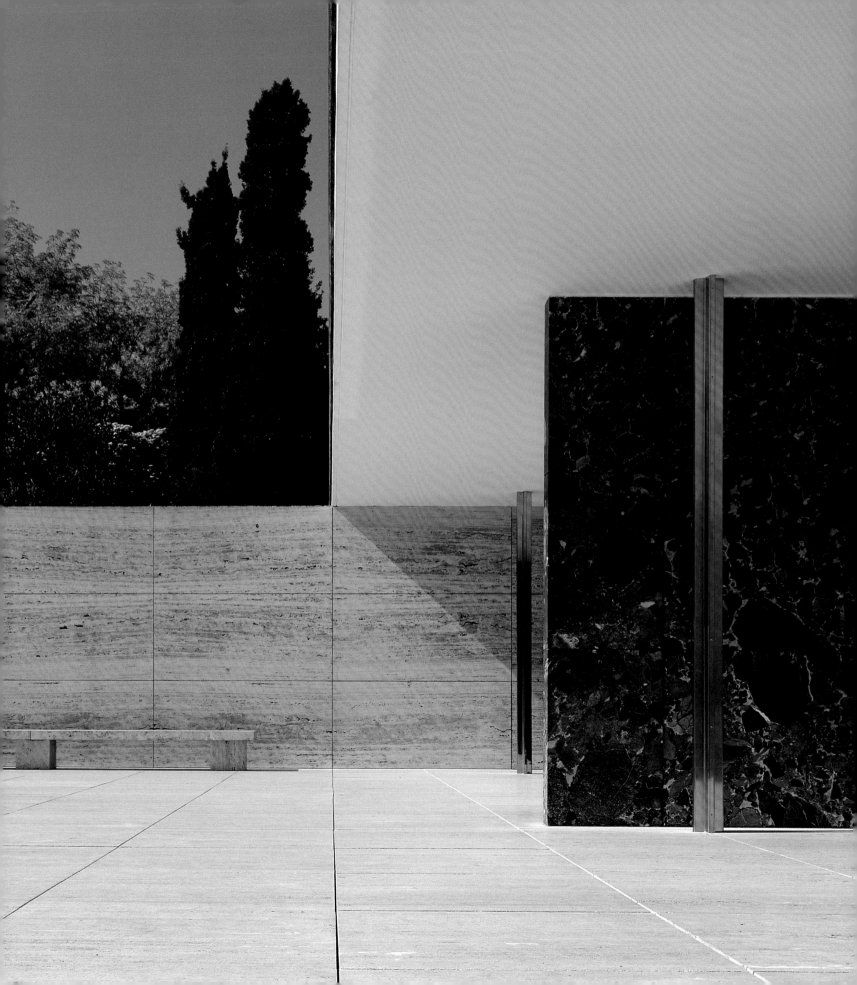

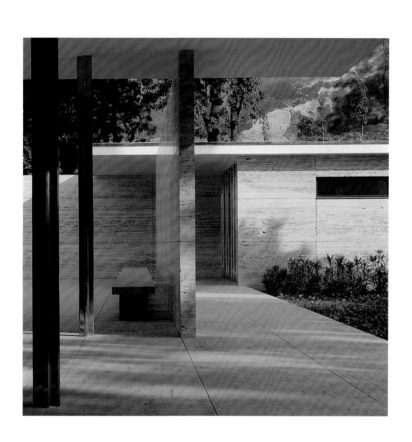

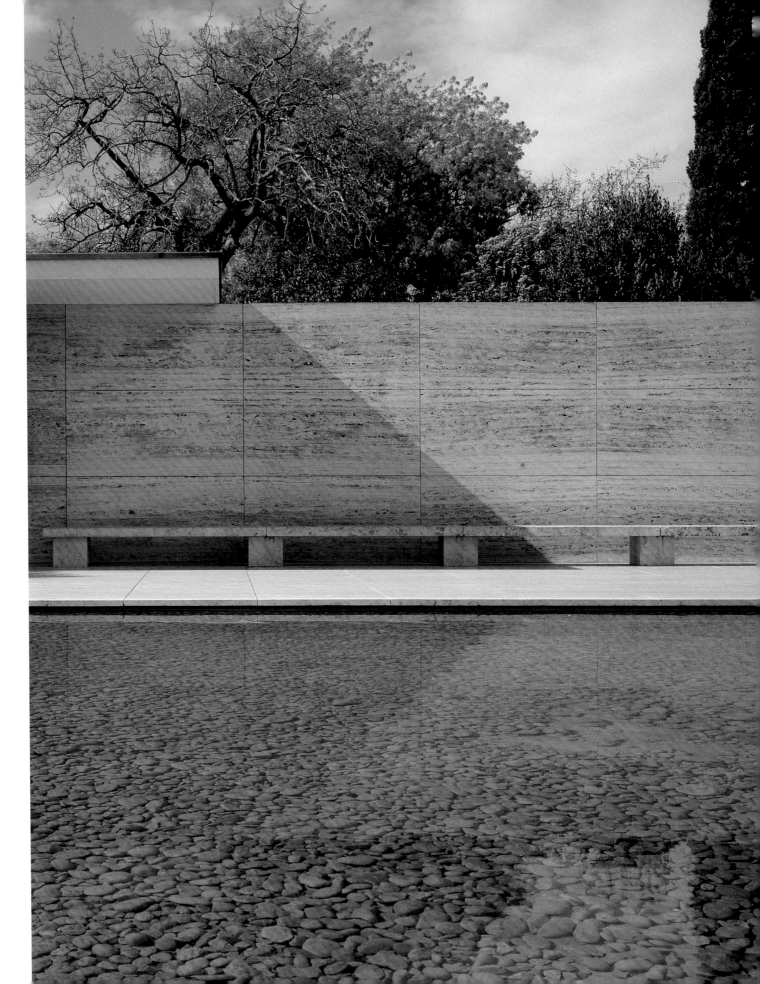

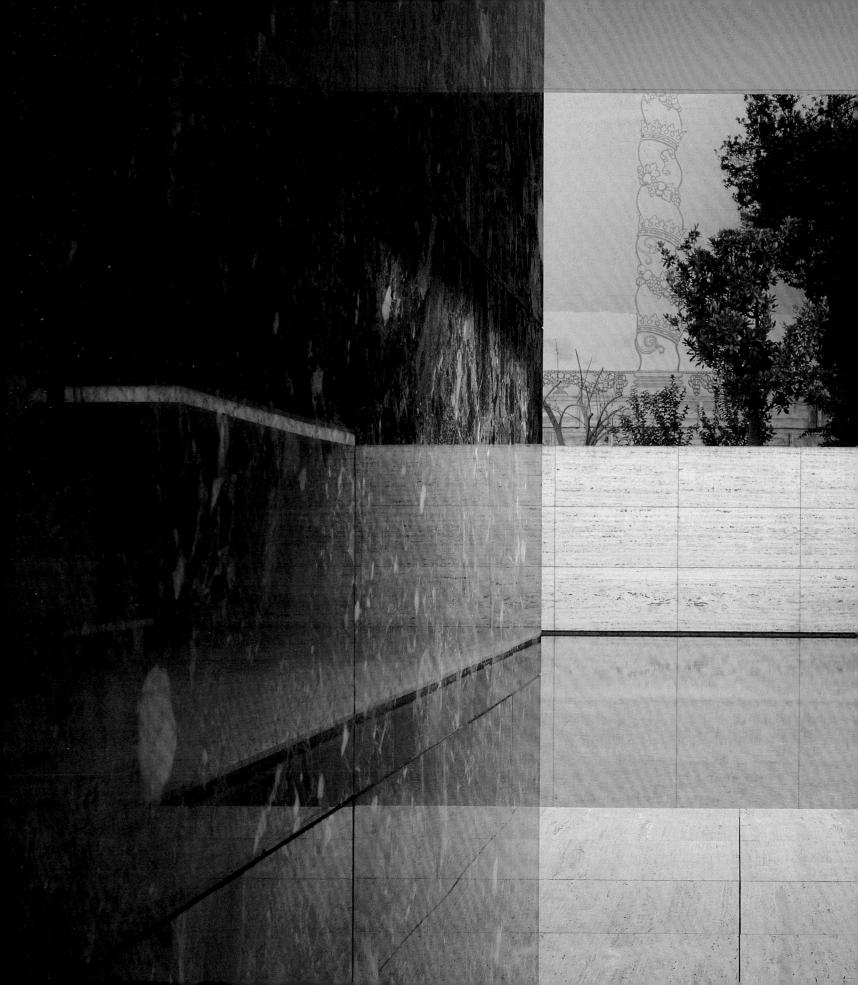

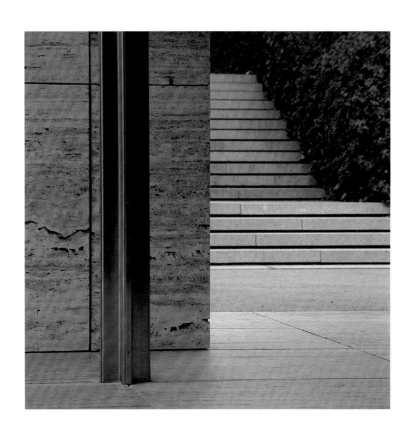

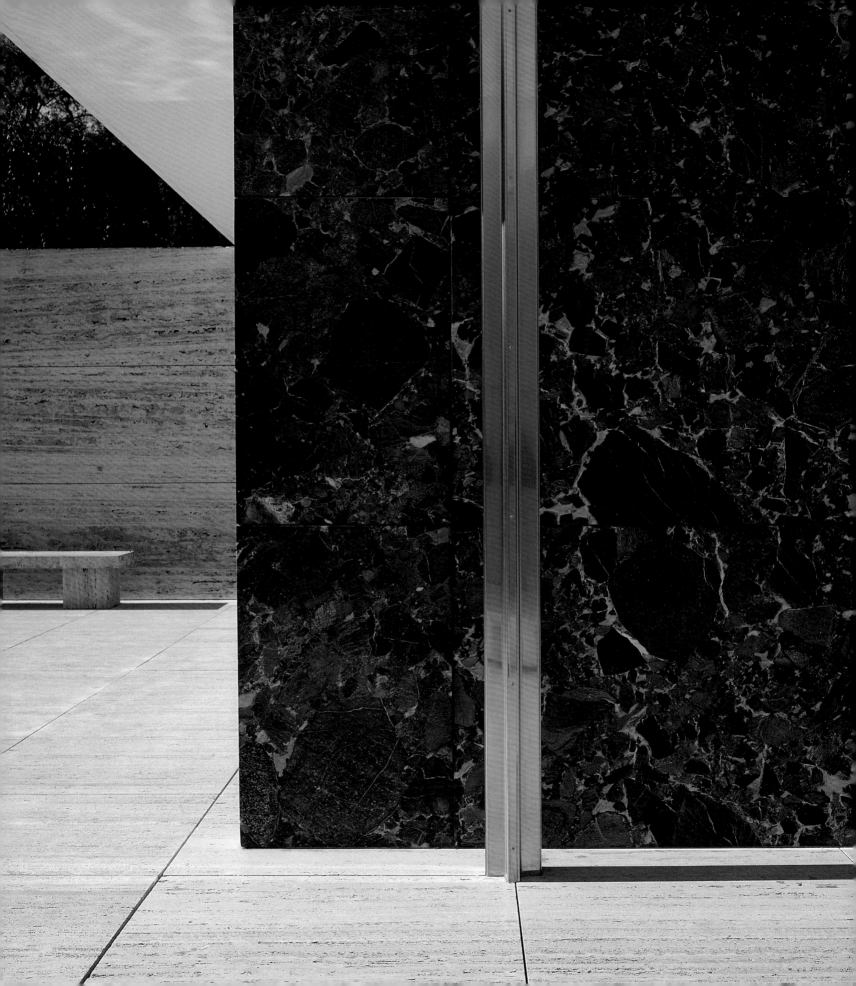

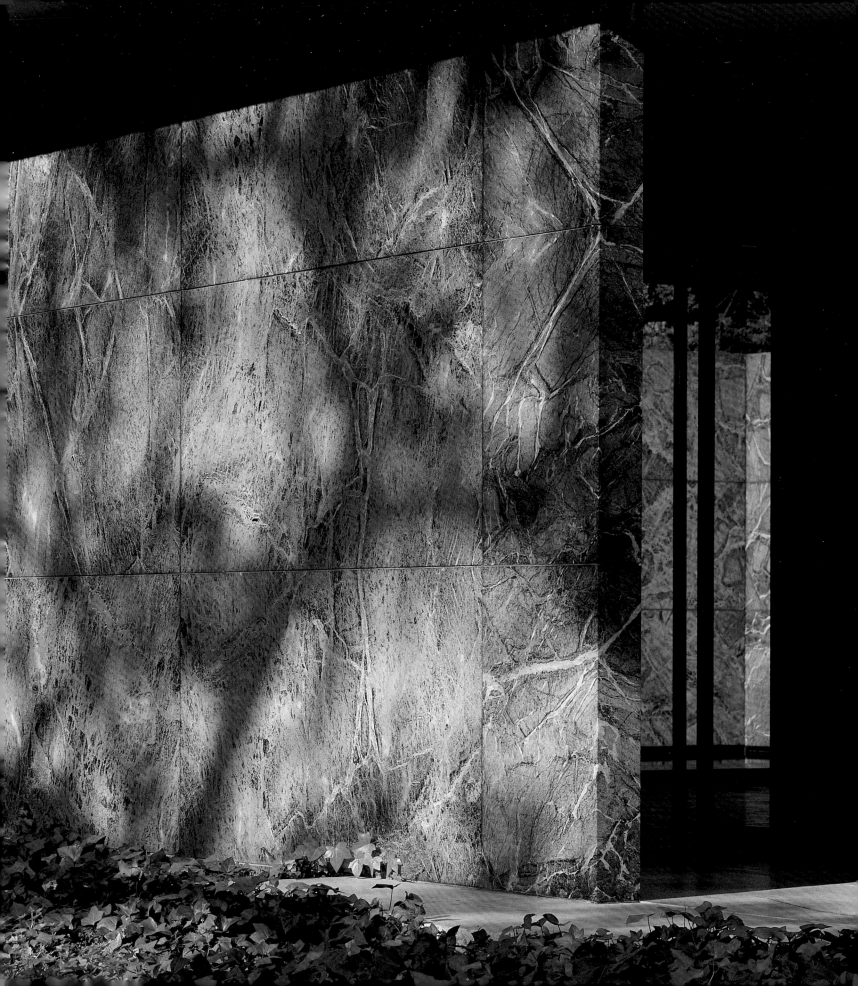

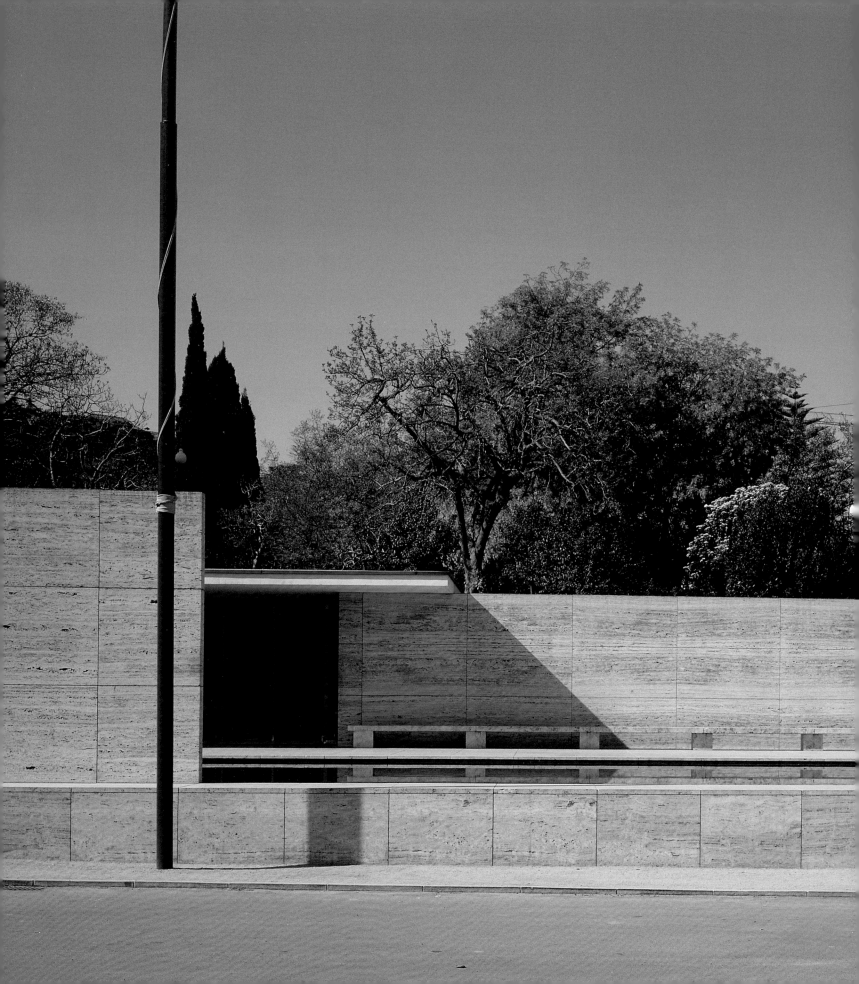

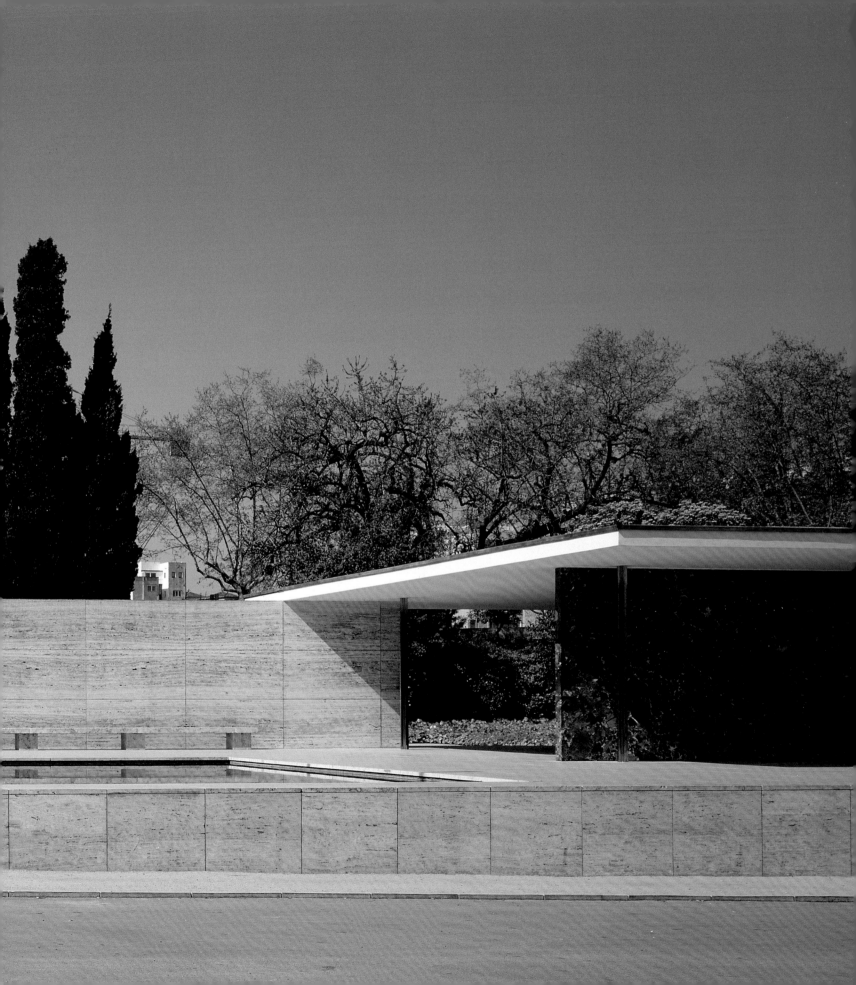

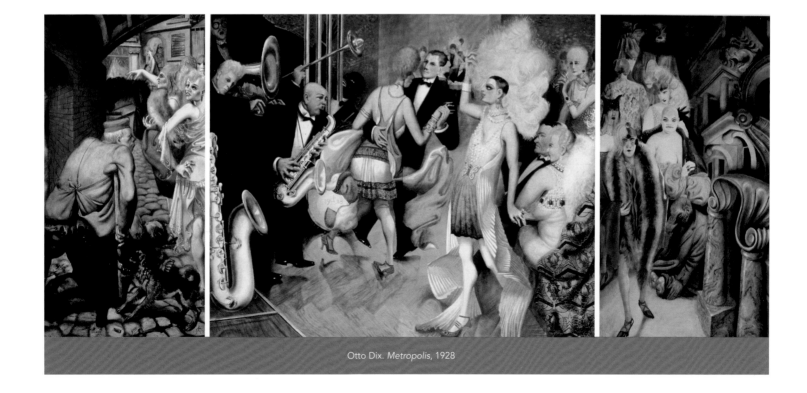

Otto Dix. *Metropolis*, 1928

# Barcelona | Berlín
## | 1929

"There is no document of culture which is not also a record of barbarism"
| Walter Benjamin

"All culture also feels the power of decadence in its inner self"
| Mies van der Rohe

**1** In the first scene of the film *Cabaret*, while the credits slip down the screen and Joel Gray is telling us that life is a cabaret for dancing and getting drunk, some golden reflections that deform the images make them even clearer in their unreality. A little later, a Berlin night-club porter is violently expelling some brownshirts who want to give out Nazi propaganda on the premises.

This took place in Berlin and must have been in 1928. Berlin, the city that Mies van der Rohe considered his home. At that time, thanks to the influence of the silk industrialist Hermann Lange, the Commissioner General of the Reich, Georg von Schnitzler, entrusted him to build "a structure to represent Germany", a *Repräsentationsraum* as the architect himself explained at a meeting of the Werkbund on the 5th of July of that year in Barcelona. Between the summer of 1928 and the 26th of May 1929, when it was officially opened by Alfonso XIII and Victoria Eugenia, Mies and Lilly Reich designed and raised the German Pavilion of the Universal Exhibition in the Catalan capital. A building which, for von Schnitzler, had to show, "... what we do, who we are, what we feel and see today. We only want clarity, simplicity, honesty." Strange words indeed if we try to examine any of the writings we choose explaining the reality in Berlin and Germany. Even stranger still if we are looking for agreement between them and the debate about the architecture of this anguished country.

In 1928, a triptych painted by Otto Dix called *Metropolis* enables us to enter into the matter. Critics have understood it as the best possible way of representing the *Zeitgeist* of Berlin in the late twenties. In the central part of work we see a cabaret scene that maybe Bob Fosse saw on thinking of his film. A jazz orchestra, with a black drummer, seems to be playing a Charleston, to judge from the steps being taken by the dancers. A world of opulence and cross-dressers surround those dancing, displaying their jewels, expensive dresses and pink feather boas. At the same time, a world of poverty and mutilation are shown to us on the side panels. This is what the Berlin streets were like in 1928, full of the excluded who begged for money while unreservedly showing almost unimaginable bare bony stumps or prosthesis, exhibited to tell us that at least they were still alive. Streets filled with prostitutes searching for clients, waiting to sell their bodies to whoever wanted to pay for them. Dix painted architecture with a crude classicism, deformed, offering an even more sinister backdrop to the street scenes of pleading flesh. Classical architecture: this is what accompanied the inhabitants of Berlin, which made up the background where their misery took place.

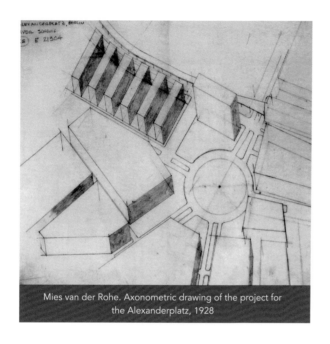

Mies van der Rohe. Axonometric drawing of the project for the Alexanderplatz, 1928

Others implored. For example, Max Reinhardt, an artist, chosen in 1929 as Director of the Festival of Munich, who saw his appointment threatened by a hostile demonstration headed by Adolf Hitler due to the fact that he was Jewish. So while Dix painted, in the Lunapark of Berlin, in 1928, 40,000 bulbs were lit up in order to exorcise the darkness and flood the city in brightness and reflections, of deformed visions which hid death and misery. Berlin must have been the Light City of Europe, an image of progress watching over such poverty. Perhaps now the words of von Schnitzler appear as an impossible dream, like a mockery of the Berliners who put up with such dreadful reality. The Pavilion did not become this dream and this mockery of an irremissibly whore-like city, a term I borrow from Angel González.

In 1928, also in Berlin, Mies was finishing the remodelling project for the Alexanderplatz. Between 1928 and 1929, Alfred Döblin wrote and published one of the best pieces of writing about the daily life of the German capital, *Berlin Alexanderplatz*, whose leading character, Franz Biberkopf, is a giant who appears to be someone taken out of Dix's triptych. Döblin relates what is seen as if he were a newspaper editor. An active doctor, he is a privileged onlooker of the Berliners' miseries. Biberkopf is a patient in the strictest sense of the term. He suffers for Berlin on each page, from his release from prison for murder to the amputation of an arm in a deliberately caused accident. He makes a living from petty theft or selling newspapers on Alexanderplatz. That is where Mies wanders, also with

his enormous figure, that which caused his students to say: "If you see two men coming towards you and, on turning, it is only one, this is Mies."

He sought strategies to decide the form of his project before drawing it. The result was an order worse than chaos that displayed the square and what Döblin exposed through his skeletal characters, murderers, pimps, thieves, con-men, prostitutes and ex-combatants. It was not the war, however, which amputated Franz's arm, but the city and survival conditions that this Berlin imposed on the less fortunate. Döblin's novel shows a kaleidoscopic Berlin, built of broken fragments, on whose streets wandered those wearing the Nazi swastika armband winning 810,000 votes in 1928 and none less than 6,400,000 in 1930 and which crossed with and fought with communist demonstrations. An objective realism, *Sachlich*. In this there are several references to Rosa Luxemburg and Karl Liebnicht, to whom Mies had raised a brick monument with the hammer and sickle in 1926. *Karl and Rosa*, the title of the fourth volume of the other grand book by Döblin that took place in Berlin in the immediate post-war period: *November 1918*.

S. Ruegenberg. Caricature of Mies van der Rohe "I need a wall behind me"

A city also has a heteroclyte culture, jostling in its demonstrations, uncontrollable for its critics, as Fritz J. Raddatz explained, in which, "instead of 'a literature' there is nothing more than nonsense, resentment and noise, nothing in common. A city which boasts 1929 as the year of its finest literary production and which was fascinated by objects, with a flood of authors who stunned. We will mention a few: Gropius, Breuer, Hubbuch, Ruttmann, Hausmann, Tucholsky, Heartfield, the Tauts, Poelzig, Pirchans. Seeing as we have mentioned Hausmann we cannot ignore what he wrote in *Hyle*, in 1933, when speaking of Barcelona: Do you like the city? Very American with the avenues and the noise from many loudspeakers at night. Much more modern than Berlin."

Berlin, where the contrast between the apparent calm and an agitated reality described by Döblin with the metaphor of black water: "...although you are only water, you are dark, black water, terrible calm water... your surface does not stir when there is a storm in the wood and pines start to bend... the storm does not approach you..." We all know that the water in the ponds of the Pavilion was black and strangely calm. We will speak of its reflections later, because now we must finish with another quotation from Döblin's text: "The wood industrialists do not give up, the Krupp family allow its pensioners to starve from hunger, a million and a half people without jobs, in 15 days, the number has increased by 226,000." Berlin the city of poverty and unemployment. Meanwhile Barcelona was having a party. How much misery would it cover up?

**2** In January 1929, when work on the Pavilion in Barcelona began, there were 2,200,000 unemployed in Germany, a figure that had risen to 3,050,000 by February. Of these unemployed, 500,000 were from the construction sector. In 1932, this figure rose to 6.2 million and 880,000 respectively.

At the end of the twenties, certain interests insisted on convincing the German public that modern architecture had collaborated decisively in expanding these figures, by insisting on the need to cover the buildings with a flat roof. Christian Borngraeber wrote that: "The Citizens Committee of Frankfurt announces the fact that the rationalisation of architecture has culminated in the elimination of entire craftsmen's corporations... the result is an increase in the number of unemployed... in mid-summer, 40% of copper workers and 75% of clay mine workers were unemployed." A modern architecture fought by its own failures. In 1929 the *Deutsche Bauhütte* magazine devoted a special issue showing the cracks in the housing at Siedlung Torten by Gropius. "Dampness, your name is May" was an article appearing in the local press in Frankfurt, in January 1931. We have moved along rather quickly: even before these dates there appeared worrying hints that sought to neutralise modern ideas. The Pavilion boasted a painfully flat roof.

Barbara Miller-Lane studied, some time ago, the first difficulties experienced by modern architecture in Germany even from the mid-twenties. It is true that at this time an atmosphere of euphoria reigned among the architects who favoured the new style. All the avant-garde strategies had produced their first results: magazines, books, conferences, manifestos and diverse groups fed the German architectural panorama with innovations, which were publicised on the radio, in the press and in some women's magazines. They spoke of the "Bauhaus style", that which defined man as "modern", of the "new Germany". To mention just one of the most aware, in 1925 Adolf Behne recognised in *Der moderne Zweckbau* that a new practical and functional architecture had been achieved thanks to the work of Gropius, Mendelsohn and Mies. A significant triad.

Not everything, however, was so clear. Konrad Nonn, Paul Schultze-Naumburg and Emil Högg, architects who held positions of great importance, began a full frontal attack on the radical architects with manifestos, books and articles. Furthermore, they used simplistic arguments that were easily accepted by the less conscious masses. It involved convincing the average reader that the new architecture was a "product of non-German culture, of a proletarian social system and part of a Bolshevik political programme".

There was also the question of the flat roof we spoke about before. As early as February 1926, Kurt Hager, the town architect of Dresden, organised a bitter debate on the question in the pages of *Deutsche Bauzeitung*, in which Gropius and Schultze-Naumburg took part. He stated that this constructive system "did not ensure the correct draining away of water and snow", and argued that, "only the sloping roof was adequate for the German climate". For Schultze the new roof represented "the

decadence of the fine architectural traditions of the 19th century". And not just this. The German Union of roofing constructors added their criticisms, given their high rate of unemployment, and called for the "German roof" as an unbeatable solution. We do not know if at that time the house in Vaucresson or those of Pessac by Le Corbusier already had their "French roof". Europe was, for all intensive purposes, a fairground of identical sloping roofs but with national denomination of origin. This was something that Mies tried to avoid at a lecture he gave in March 1927, precisely when he was helping in the construction of the houses at the Weissenhof, all finished with a flat roof and whose opening was planned for July of that year: "The architectural movement also maintains its emblematic struggle... Nevertheless, it is only a struggle for exteriors, although many leading figures take part in it. It has nothing whatsoever to do with the battle for the rules of a new architecture."

Nationalist and racist were the bases of the arguments that continued against modern architecture. At the end of 1926, Högg gave a paper at the "Congress of German Architects and Engineers", calling it "rootless" and "nomadic". His talk seemed to be a preface to the widely published photomontage in 1934, where we see the homes of the Weissenhof, planned by Mies in 1927, turned into an Arab bazaar with camels and lions. Berbers, nomads. Of course, was it not nomadic life that so clearly defined modern man in the best demonstrations of German culture of the time? Did not Loos, Musil and Hilberseimer write that the best way to be modern was to live in hotels, constantly changing residency and relationships? Were these defenders of the sloping roof contrary to anything modern, or contrary to the non-Aryan races? In 1926 Hans F. K. Günther published *Race and Style,* trying to convince anyone who would be taken in that "the racial characteristics are reflected in art". While the average German meditated over such a transcendent question, the town architect of Hanover, a mediocre fellow called Albrecht Haupt must have seen the light, and began

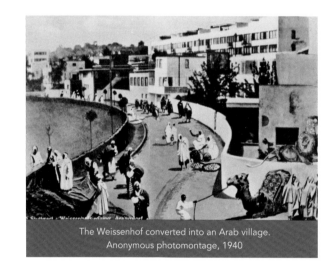

The Weissenhof converted into an Arab village.
Anonymous photomontage, 1940

to insist on the idea that the sloping roof was something that formed part of the "German racial physiognomy". On the 1st of July 1933, Max von Schillings, President of the Prussian Academy of Arts, asked for the certificate of racial purity of Mies van der Rohe. In March of the same year, the Nazis had opened the camp of Dachau.

Let us leave this topic and commence on another, related one: in 1928, Schultze-Naumburg, for whom we do not believe Mies felt any great fondness, published *Art and Race* and *The aspect of the German house.* We cannot help thinking of the first title published by Gropius in the collection of books from the Bauhaus, in 1925, called de *Internationale Architektur.* Let us return to Schultze-Naumburg, however. His first text abounded on the topics mentioned and added architecture as a contributing factor of racial values. The second subscribes to a common concern in

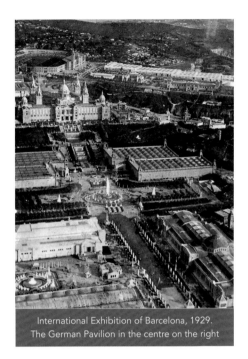

his time, the ideological obsession of knowing what the German house could actually be, something that we are also grateful to Miller-Lane for the information provided by her work. Schultze-Naumburg's pulse must have been racing when he wrote: "houses have a face", and it was not that the German house was fair outside and had blue windows, but that up until the time of Goethe, it had "a harmonious and very high level face: it was like the face of upstanding, good and sincere men". He was saying absolutely nothing, which is why it was so successful within a specific political ideology.

Of course, in 1929, Freud had already taken care of demystifying this nonsense when, analysing the roots of the word house-home, its meaning had been distorted. From cosy and comfortable it had come to suggest dark and sinister. Who then, were these modern types, to amend the pages of so much tradition? What did these sliding windows, these white, pure, boxes, crowned with a horizontal sharpness, aggressive for the ideals of these German-German people, actually represent? Or is it that those who did not want to see the claustrophobic and sickly aspect of family relationships that occurred inside the house did not find it cosy? The text by Richard Pommer and Christian Otto has informed us in a detailed way of the furious reaction of some of the Stuttgart architects against that white phantom that from its hilltop threatened the city in 1927. A phantom that we have already mentioned was raised by Mies van der Rohe. We must not forget it.

Returning to Schultze-Naumburg, "The German house", he said, while showing examples of his own buildings or by Tessenow or Schmitthenner, "gives the sensation of growing from within the earth it stands on, like a natural product, like a tree sinking its roots into the depths of German soil and forming a oneness with it". Mies was tired of saying that in his buildings he looked for "effects", something which perhaps did not make him far-removed from Schultze-Naumburg. Between effect and sensation, between Monet and Cèzanne, aspects of painting over the century, rather dated things in the time we are dealing with. In contrast, the houses of the radicals, "seem to have been assembled in any old way and placed anywhere by an intermediary, as if they could be there or anywhere... They are camping vans fixed to the ground... They are the product of the nomads of the metropolis..." Once again the modern ones are like nomads, inter-nationals.

We know, from the essay by Wolf Tegethoff, of the care Mies took in the placing of the Pavilion and his desire that the building would fit the place it had to occupy in the babelic setting of the Exhibition of Barcelona. Perpendicular with respect to the enormous and solid mass of concrete by Puig i Cadafalch. Horizontal, an exaggerated size due to the great extension of the travertine walls that fled from that madness. Horizontal

standing up to an emphatic vertical. Dual structures, which Mies learnt from Romano Guardini, which are a distant reflection of Greek thought which Mies's mentor used in his texts. Guardini, who wanted to renew platonic thought. Dual structures. In 1928 Mies wrote some notes called "programmatic points" where we read: "Liberty and law, flow and order, dominion and service, subjectivity and objectivity. Violent totality. Essential order full of meaning. Inside out and outside in. Inner order instead of organisation. Existential being through the spirit. The inner world and the will of expression."

Symmetrical to the pavilion for the city of Barcelona designed by José Goday. Behind an Ionic colonnade that threw none-too-innocent shadows across its shiny walls. As a passing place in the crowded walk towards the Pueblo Español or as a place to stop and rest. The pavilion, with a pedestal that tied it to the ground. In its place. Rooted. A German-German dream? Or modern, and international, read from Germany but without possibilities of being there, given that for some Germans who knew Mies – we cannot forget the photograph of the enormous hulk of Mies visiting the Dada fair in Berlin in 1920 where Hausmann was one of the stars, Hausmann who Mies knew well – was Barcelona more modern than Berlin?

Juanjo Lahuerta came across a stereoscopic photograph of the Pavilion and around it the best thing I have read about the building by Mies. It shows us the people crossing the pavilion indifferently, a long way from the other images of the era, "nearly always solitary and empty". Using it just as it was, a short cut for a rainy day. Of course there are other types of photos. Those that are shown as a stage with people wearing top hats. Mies as well, on the day of the opening, the 26th of May 1929, seven days later than the official opening date of the Exhibition. Without the lodge house completed and the gardens in a sorry state. German efficiency, German precision. Or, in other words, all that was German, far from the mythicising dreams of Schultze-Naumburg, was reduced to this, a passing point from which one escaped or ignored or an ephemeral spot that was seen to be incompetent, incapable of meeting the deadlines for a piece of work. It

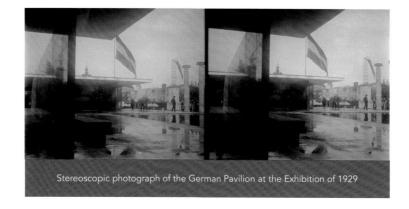

Stereoscopic photograph of the German Pavilion at the Exhibition of 1929

was a place of representation for a few fleeting minutes. What are we left with? All the things that von Schnitzler wanted to show are slipping between our fingers.

At a lecture given on the 17th of March 1926, Mies wrote: "It is now the princes' palaces that have a decisive influence over architectural evolution." The Pavilion was meant to be a prince's palace, of a prince who would inhabit it for a few seconds. In 1929, while a photograph shows us Mies storming out of the pavilion with an angry air, probably for not having managed to get the monarchs to sit on his brand-new Barcelona chairs, other texts attacked the modern thinkers with new arguments added to their racist obsessions.

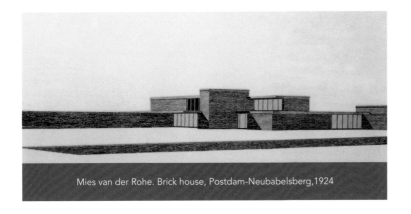
Mies van der Rohe. Brick house, Postdam-Neubabelsberg,1924

For example, Alexander von Senger began with the same old story of bolshevism: "It is a well-known fact that communism infiltrates with its secret agents... and spreads its doctrine through "art films". The movement that goes under the innocent name of "new architecture" is nothing less than Bolshevism... Marxism supports the new architecture because it creates new proletarian masses." Just what was needed. If the pavilion belonged to new architecture, we would like to know what its ability could have been to create proletarian masses who could have afforded its expensive materials. Or perhaps it was more that in Germany nobody knew what this new architecture was and nobody was speaking about architecture except in a way to take positions, of forming powerful cadres who, within a short period of time, would occupy key positions in a renewed administration. In 1929, the KFDK was founded, the League of Combat for the defence of German Culture with Alfred Rosenberg at the head, who would continue to launch stern proclamations against modern art and who would have a violent confrontation with Mies that we will recount later. In the minutes of the first general meeting of the KFDK, we read: "Amidst today's cultural decadence we will instruct the German people about the interrelationship between race, art, culture, science and moral values." Exaggerated discourses, befitting the crazy cultural debate that was being produced in a country excessively agitated by unemployment and inflation.

The final madness of these arguments is explained by Miller-Lane: "At the beginning of 1930, the 'Ludendorffs Volksware'...came to the conclusion that the modern architects were working for, 'the total destruction of the German house... in favour of an international civilisation that replaces the soul with a machine, to transform the German into a collective entity... the ideal type for Bolshevism." Judging by some of Mies's projects which include that of the Pavilion, it is not difficult to state, as has already been done, that the pavilion is a house, but is it a German house, a Bolshevik house, a house that imposes "foreign ways onto the German family", onto this "race that deeply loves the house"? After what has been said, we do not know whether to be suspicious or joyous for the fact that the Tugendhat house, planned almost parallel to the pavilion, is also not in Germany, or that the "Concrete country house" by Mies in 1923 and the "Brickwork country house" of 1924, essential precedents of the Pavilion, were ideas only expressed in plans or models. They were never possible in Germany.

In his obsessions, Senger is capable of reaching unsuspected limits, though interesting for our purposes, inasmuch as it shows an unconscious collective, a spirit of the time. If it can be said that works of art and architecture can be imposed on the race, this correspondence has remote origins that modern thinkers ignore. "Our culture has been penetrated by a deep inhalation of the great health of

Tradition". Against the disease of the modern, the health of the old, something that Senger exemplified with classical Greek models, Greeks, evoked by the actitude of its artists in their clear-sightedness: "It was not Greece that made Homer, but Homer, through his poetry, that first made Greece." Later, when it comes to specifying how the architecture should be that would resolve its afflictions, he insisted in what he imagined to be heaped with "national components... mythical and symbolic".

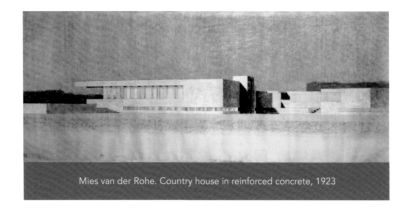

Mies van der Rohe. Country house in reinforced concrete, 1923

Greece and the need for myths have crossed our path with a disturbing presence in the German debate of the twenties. If the Pavilion is a house "in the widest sense of the word", a German house that we know, through Elaine S. Hochman, the negative of Mies on placing on its facade the emblem of the Reich, the eagle, should it not show its Greek origins in order to be exactly German? Or to be necessarily modern? Must we remember once again how decisive Greek architecture was for modern architecture, from the interpretation of it provided by Le Corbusier in the pages of *L'Esprit Nouveau*? A Greek house, closed, inaccessible and moveable all at the same time. Sacred and vulgar? Dual structure, Greek thought. Tegethoff stated the closed nature of the pavilion in his essay in 1981: a distant echo of the article by Rubió i Tudurí published in the eighth issue of the magazine *Cahiers d'Art* in 1929. Or of that written by Drexler in the late 50[s].

The dark-green marble of the pavilion must have come from the Greek island of Tinos. Already in 1905, Julius Meier-Graefe wrote: "Would it not be possible to build in a way that does not reproduce the form, but the cold spirit of the Greeks, so worthy of praise?" Greece, a known resource. Nietzsche commented on these intellectual mechanisms. Mies knew his work thanks to Peter Behrens and Alois Riehl, a professor of philosophy who in 1907 had commissioned his first building. Nietzsche, who wrote: "Paraphrase a known speech, maybe habitual, convert it into an all-embracing symbol and thus suggest a whole world of deep sense, power and beauty in the original subject matter."

**3** Cold spirit of the Greeks. Dual structure. Alongside eternal stone elements, others of a distinct nature. Glass, for example. Not less German, naturally. From stone to glass. A sinister figure took the trouble to enshrine these two materials in time. It was Hitler who, in 1929, announced that when his party took power, from its "new ideology and our political willpower of strength we will make documents of stone". On the 1st of September 1933, he said: "The needs of today require new methods ... (we need) a clear and transparent functionalism like glass." From stone to glass, Hitler too. As occurs in the Pavilion.

Shortly before Hitler spoke, on the 13th of March, Mies had written a text for the German association of reflective glass manufacturers which was not published and which Fritz Neumeyer found amongst his papers. Its title was unusual, *Was wäre Beton, was Stahl ohne Spiegelglas?* "What would concrete and steel be without reflective glass?" Mies wrote: "The power to form spaces of both would be limited... it would be a mere promise. Only the skin of glass, only the glazed walls enable constructions made with a skeleton to reach their univocal structural form... to enable a degree of freedom in the configuration of space, that which we do not wish to do without. Only this way can we structure spaces freely, opening them up to the landscape and placing them in relation with it." A very similar text to the work of Sigfried Ebeling, a member of the Bauhaus who Mies read and who in 1926 wrote *Der Raum als Membran*, "Space as membrane". The combination of glass and structure are resources that open architecture to the landscape. Glass and steel skeleton appear in the Pavilion as membranes. The landscape is also there, in the way in which these materials announce it. A condensed future that lies ahead. A future lying in wait that can be materialised in the idea of house that Raoul Francé defended and who Mies also read: "... (the house is)... a state of transition of a flow of energy... a continuous flow". The Pavilion, a German house where we can verify it.

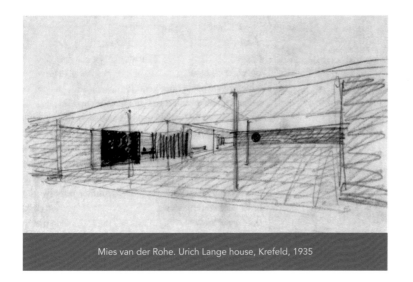

Mies van der Rohe. Urich Lange house, Krefeld, 1935

That which best enables us to understand something about the Pavilion is this being between, suspended from conditions which made it possible and those which announce it. The relationship between German culture and glass come from far away and progress with distinct meanings. Those of Mies too. In 1914, Bruno Taut built the pavilion for the glass industry in the Werkbund exhibition in Cologne and Paul Scheerbart wrote *Glasarchitektur*, on whose first page we find the dedication to Taut. From the same year came one of the last important paintings of the expressionist artist E. L. Kirchner, *Bridge over the Ring in Cologne*, in which we see the arches of a bridge structure that leads to a cathedral. In 1917, W. Worringer published *The essence of the Gothic style*, in which a German nationalist sentiment, displayed to overcome the trauma of the impending defeat, is embodied in the cathedral, a building of glass, which is lost, "in resonance that is propagated by the infinite".

After the war, with Germany defeated, confused and humiliated, the storm died down. Moholy-Nagy insisted on a bridge-building exercise between the before and after of the conflict by painting a series of pictures entitled *Glassarchitektur*. In January 1919, in order to imagine fresh air, Walter Gropius wrote "The archi-

tecture of the free popular state", in which we find: "The current generation must start from zero, rejuvenate, create a new community… Only then will art be born… Architect means *Führer* of art… he should bring together artists encouraged by the same interests and feelings – like the masters of the Gothic cathedral in the medieval councils – in this way the future cathedral of freedom can be built." Mies and Gropius were both members of the "Novembergruppe". In April of the same year, Lyonel Feininger designed the cover for the manifesto and programme of the Bauhaus: a Gothic cathedral capturing the light of three stars and projecting a pattern of sparkling reflections into the air. It announces the dawning of a good new beginning, a hope for a better future, far from misery and disorder. We could mention more names and figurations that abounded with these ideas. Also in 1919, Bruno Taut insisted on his *Alpine Architektur*, plagued with houses, mountains and glass cathedrals. Perhaps a year later he had tired of the game because, in *Der Weltbaumeister*, the images of upright cathedrals are mixed with those of these same buildings crumbling away.

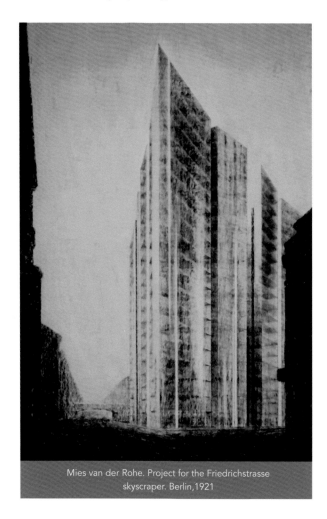

Mies van der Rohe. Project for the Friedrichstrasse skyscraper. Berlin,1921

It is in the fourth issue of the magazine *Frühlicht*, edited by Bruno Taut, published in 1922, where Mies publishes his two versions for a glass skyscraper to build close to the Friedrich station of Berlin, the result of taking part in the competition held the year before. Mies writes that: "A prismatic form seemed to me the right solution to the problem and I decided to give an angulation to each side, in order to avoid this sinister effect (in some translations we read fading) which appears when using glass over large surfaces. The experience I had with a glass model showed me the way and I realised that what mattered when we use glass are not the effects of the light and shade, but its authentic play of luminous reflections." Effects yet again.

Sinister or fading, it does not really matter. The glass of the death throes of expressionism have faded. There is no longer that cathedral full of light thanks to glass, redeeming, gatherer of believers in a better future. Against this, Mies warned of the sinister that lay behind any form of nostalgia or utopia that continued in that post-war Berlin. He liked repeating that he was not interested in sentiments. In 1924 Mies was unequivocal: "However much we go deep into our concepts of life we will not build cathedrals."

Now, therefore, it is about proposing a different image for this glass that he wanted to be the consoling factor of defeats and fiascos, the shocked protector of a nation without future: the reflection, which repeats only that which exists. "Spaces in which it is difficult to leave behind traces... glass is a cold and sober material. Glass objects do not have auras", said the German materialist philosopher Walter Benjamin during these years. In an interview in 1964, Mies remembered that when asked what would be the function of the Pavilion in Barcelona, the answer was: "We don't know, just build a pavilion, but without much glass."

Between the 23rd of July and the 9th of October 1927, Mies had to deal with glass. This time in Stuttgart, at the Werkbund exhibitions. It was through a commission from the German Association of glass pane manufacturers, who had their headquarters in Cologne. In the fourth pavilion of the show in the Stuttgart Stadtgarten, Mies built the *Glasraum*, an idea for house built completely of glass, with all its functions identifiable through the rooms designed by Mies and Lilly Reich: lounge, dining room and workroom. A place that connected to a third hall – given over to producing German linoleum and also designed by Mies in conjunction with Wili Baumeister – with the outside. Restful and smooth, something we would come across later in the pavilion of Barcelona. Mies and Reich conceived a labyrinth made up of flat surfaces in a bright metallic structure and different shades of glass. Each visual end of the walk finished in a fictitious outside space, with a gardened courtyard or a female torso by Wilhem Lehmbruck. Ground plan labyrinth, spatial labyrinth increased by the reflections.

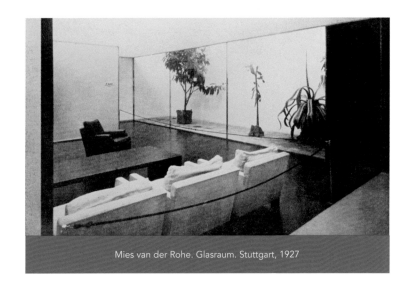
Mies van der Rohe. Glasraum. Stuttgart, 1927

Wolf Tegethoff describes the colour of the glass to us: grey, green, transparent, glazed, engraved on one or both sides. A labyrinth of reflections, with a linoleum floor in white, grey and red. Flat glass, now without strange leanings. Sinister? Reflections and reflections of reflections accompanied the visitor from Stuttgart who saw it countless times, in all the ways that were possible in their eventful trip around the *Glasraum*. Mixed between the furnishings and the torso, the spectator was between two instances: that of the statuary which specifies, defines and values, and that of technique. Between the old and the modern, between the past and the future. This is repeated in the Pavilion: between the marble and the glass. To move forwards one must move backwards. Mies had built time making the possibility of thinking only in the present something perceptible, from a present conditioned by history. The image of the labyrinth, of a labyrinth that we still do not know if it will lead us to a possible or final redemption, opens up more questions.

**4** The labyrinth, one of the privileged places of mythology, belongs to the fantasising imagination of architecture. We have read so many times that Dedalo was the first architect. He built the labyrinth for Minos. Or that it was Ariadne, thanks to whom Theseus had his back covered. Ariadne, a woman. The statue by Kolbe that Mies placed in the Pavilion, like the torso in Stuttgart, represents a woman's body. Now the order does not matter. What counts is the archetypal image which the architect needed to refer to provide us with a house, a glass house. The ritual space in which reason triumphs over disorder. In Minoan culture there are representations of labyrinths in the form of a swastika. Labyrinth, place in which the materialisation of the encounter with death is sought. In 1929, the same year in which the Pavilion was built, Walter Otto published *Die Götter Griechelands*, "The Greek Gods", supporting the idea that archaic thought is the monumental essence of rationality.

An archetypal gesture of which Maria Luisa Reviglio has shown us the need, "of serving the myth and the memory as mental categories that allow for periodical returns to the underlying time in which the roots of his destiny are condensed". A place where man becomes conscious of himself and the spirit of the era, in other words, the collective unconscious, of the "Zeitgeist". In 1923, Mies had said: "For architects, architecture is not a theory nor a speculation or a doctrine, but the spatial expression of the spirit of the time. Alive, changing, new." A year later an article was published in *Der Querschnitt* in which, referring to the Greek temple or the cathedral, he said: "These constructions are, in their essence, completely impersonal. They are pure carriers of the spirit of a time. Here lies their deepest meaning. Only this way can they become symbols of their time." The flat glass, tinted, in big dimensions, a material of modern times – industrial Germany. The labyrinth, the structure that possesses an immemorial time, legitimises it.

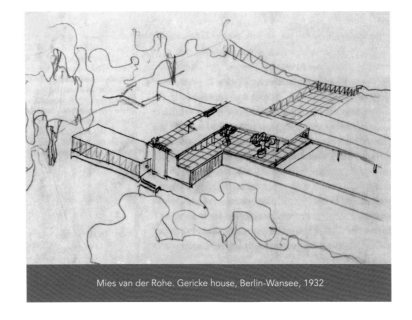

Mies van der Rohe. Gericke house, Berlin-Wansee, 1932

For Walter Otto, a confessed admirer of the German romanticism of Hölderlin and Schelling, the myth represented an immediate illumination, which unexpectedly interrupted the human spirit without any logical means whatsoever. All this is close to the idea of architecture that Mies defended, far from speculations, doctrines or recipes. That which was initial, unconditional. What does the unconscious belong to? In 1930, Jung was named honorary president of the German Society of Medical Psychotherapy. Jung, who revealed the mechanisms of the unconscious, for whom the individual is a social being and the human spirit a collective phenomenon.

The labyrinth, "the emblematic form of complexity, the plan of the path of knowledge... a structure of thought... sinks its roots in the myth and in the search for the sacred". The labyrinth, where, "reality and the spirit are joined". In 1926, Mies wrote some notes for a lecture: "It may be interesting to trace the spiritual impulses of an artistic period and clarify its formal problems. The spiritual forces of a period may also be efficient here." In the preface of the official catalogue of the Exhibition of Housing organised by the Werkbund in Stuttgart in 1927, Mies wrote: "The problems of new housing have their roots in the changes that the material, social and spiritual structure has experienced in our times... The problem of new housing is basically a spiritual problem." The spiritual, a subject in which Mies had already emphasised in a lecture in 1926, on understanding architecture as, "the spatial consummation of a spiritual decision... in no other era has it been any different". Neumeyer insists that the influence of the architect Rudolf Schwarz was determinant in these words.

**5** We have said that the Pavilion was a house. A house which, as Mies said, should be considered configured from spiritual aspects that the will of the period demanded. The house, where also reality and myth from remote times would also converge. Jean-Pierre Vernant has informed us that Hermes and Hestia, Greek goddesses, would bear witness to it. The house, the arcane place that Mies had been tracing since 1923, when he was interested by the primitive cabin, the same time as he planned the "Country house of reinforced concrete", shortly before the "Brickwork country house". All of them, as we have mentioned earlier, preceding the Pavilion, such as the Glass Room of Stuttgart in 1927. Therefore, the Pavilion is only possible when all that has gone before has been possible and when we have crossed the path of Greece, a place where the reflections from the mirror have important meanings which we cannot omit.

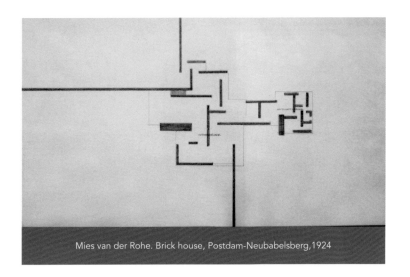
Mies van der Rohe. Brick house, Postdam-Neubabelsberg,1924

Mies needed to lean on Greek thought to express himself. Just like many other Germans of his time. The words of Jean Clair, analysing the cultural situation in this Germany are categorical: "The situation of paranoia that the German conscience found itself in during the twenties, and from which Nazism was to achieve its triumph, enabled the idea to be hatched that the German people, in their purest form, were the legitimate sons of a heroic race that had populated the ancient Germania before colonising Greece." In 1926, in a paper by Mies for a lecture we come across something important after he says: "Plato already recognised the change in forms of state and of society and thought that the cause of this transformation was due to a change in the transformation of the people's soul..."

Glass, metallic, stone and water reflections, together with a thick woollen carpet, over which Mies placed the chairs for the monarchs. Perhaps they do not represent worlds as far apart as their appearance suggests... "His tunic was the mirror image of his body", Homer's *Odyssey*, VI, 75.

Let us return to Plato in order to continue with the person quoted by Mies and who opens up the way of understanding the reflections of the Pavilion. In *The Republic*, 508 c/ 510a, we find: "I give the name of images, firstly to the shadows and then to the figures reflected in the water and in everything that is compact, smooth and shining and, if you see what I mean, to everything that is similar to this." A contrast between image and reality emerges from the text. Tiresias went blind for daring to see the reality of Athena, that is, because he saw her naked. Athena, who was clever, reasonable, virtuous, truth incarnate.

Was the reality of Germany in 1929 something that could be faced honestly? Mies asked the question: "Can mankind put up with the world as it stands?... Can it become worth living in?" After what has been said we should have to give a negative response to the question. The meaning of the reflection in Greek culture begins to become clearer. Both Vernant and Françoise Frontisi have spoken about

Roof of *De Stijl* 6, no. 5, May 1923.
Filmmoment by Hans Richter

it at great length: "In a face-to-face civilisation, characterised for seeing and being seen... the visual rays emitted by the eye and those which, returned by reflecting surfaces allow us to see what we are looking at, the rostrum-mask, the eye and the mirror... all lead to the Greek problem of the visible and the invisible, of life and death, of the real and the imagined." Vernant emphasises, on reminding how, at the exit of the sanctuary of Lycosura, in Arcadia, a mirror was found embedded into the wall. Pausanius (VIII, 37,7) wrote of this mirror that: "If you look at this mirror, everything you see will be misty or you will see nothing at all, but the images of the Gods can be seen very clearly." The mirror only reflects, integrally, the image of God, the superior being to man, who can hardly recognise himself in the mirror. Superior because he has an inherent existence, not a conditioned one. Precisely that which man can never see face-on and from which only an image can be perceived. To the mortal, the mirror reminds him of his temporary nature. Looking at Gorgona, at Medusa, she kills, she carries death in her eyes. And she does it transforming us into stone, petrifying us, making us opaque to the rays of light, stopping us from exchanging reality in image, from living. Without reflections, alone with our reality which we do not like accepting. Medusa is the figure of chaos, the return to formlessness. Another type of reality, as unbearable as that of the untouchable Athena. Medusa, who was always represented face-on in the bottom of Greek wine glasses, with her enormous killer eyes.

"Bronze is the mirror of the form; wine, of the heart", said Aeschylus. In Alcaeus we find: "Wine is a mirror for humans." Finishing the wine and under its effects, the Greek saw Medusa. How much Mies liked drinking could only be told to us by those who knew him, but we have enough witnesses to his liking for alcohol. Franz Schulze and Elaine S. Hochman mention it in their work. Medusa, excessive in her stare, symbol of death, who appeared with a face-on stare, enormous eyes, mocking, savouring the triumph of her presence, reminding one of the certain death of all humans. Face-on, emphasises Frontisi, contrasting this with the almost absolute presence of the profile we find in the figures represented in Greek ceramics. "The explosion of divine splendour is too intense for the human eye to cope with." Death, the other. God, the other. The mirror does not reflect horror. It is horror, the absence of truth.

In the Gynaecium

The woman, the other, from which Weininger published *Sex and character* in 1903, Loos was concerned with female nudity in similar vein, or Kirchner devoted a great deal of his energies in painting prostitutes with feathery bonnets who wandered the streets of Berlin from 1913 onwards. The pages of *Der Sturm* insist on presenting us with the condition of the woman in the German time of the machine. Everything comes back to Berlin. They all return to Berlin, Helen, Clytaemnestra, the women of Troy, Medea, although this could only be done, in 1929, from Barcelona. Ulysses states that: "The green fear gave me the idea that Persephone could have sent me the head of Gorgon, this terrible monster." The marble of the Pavilion and its reflections were green. We have already mentioned the fact that it was Greek marble.

Aristotle in *On the Soul*, II, 8, wrote: "Water is where light is best reflected." Seneca repeated the same idea. Many years passed by between the classical philosophers and Döblin but it seems that the German writer found the need to evoke the early ones. Making them present, making them modern. Behind the water reflection, once again, death, this time of a man. Narcissus, of whom Tiresias prophesied would only live if he avoided seeing himself. But Echo, in love with Narcissus, won, as Ovid tells us. Of course Aristotle had already pointed out to us the similarity between acoustic and luminous reflections. Frontisi states: "But the motive is illusion, which prepares and forewarns of the episode of Echo. Narcissus, tricked by the division of the voice, is also tricked by the division of his appearance." And the price of losing oneself in illusion is also death.

Ulysses resisted, tied to the mast of his boat, while the crew plugged their ears with wax. Can the truth only be heard or seen with hands and feet tied? In another of the

last scenes of *Cabaret*, it is the Nazis who are brutally beating up the doorman of the club and Fosse also makes us see it happen through reflections. Either the Germans did not want to face the truth, or they were just not aware of what was to befall them. There is not much difference. Mies understood it well: "Matter, things, are only given to us as images, like ideas, but in no way whatsoever in themselves." Mies wrote a capital B next to this sentence which must have tortured him. Buddha? Buddhism?

He knew it and surrounded us with reflections, the height of falseness. Mies, who would not build what he thought. Or he knew that what he would build was illusory. In 1928 he had noted down a phrase by Saint Augustine that enables us to confirm this: "Beauty is the resplendence of truth." Therefore, the Pavilion could never be beautiful.

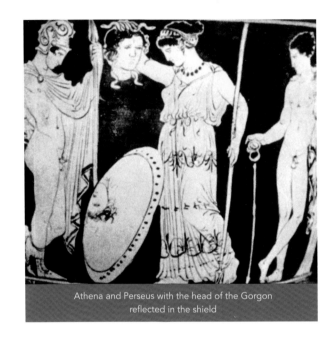

Athena and Perseus with the head of the Gorgon reflected in the shield

Athena allowed Perseus to kill Medusa because the reflection of his burnished shield showed her image. The mirror controls and allows the myth to be led. Surely, though, we are just faced with a scene of jealousy between two women and Perseus should be seen as someone who has been callously used. Medusa, a trophy for Athena. "The Greek mirror is something distinctly feminine." The mirror, something for women for the Greeks. Aristotle pointed out that mirrors form a bloody image when whoever is looking at herself in it has her period.

Mirrors were offered to the Gods. Hera held the mirror in the judgement of Paris. Vernant and Frontisi show us eloquent Greek images of women between the mirror and the spindle. "Mirror and spindle are mixed up in the image because, together or separated, they co-exist with the same series of objects. There is a connection between the mirror and the act of weaving, also belonging to femininity." Woven fabric, an insinuating material in women's sexuality. Athena weaves her tunic to emphasise her virginity, or that of Hera in order to arouse the love of her husband. Helen or Aphrodite also contemplated Paris. On Greek vases the woman never appears naked. Was it not Adolf Loos, that architect who Mies vetoed in the 1927 Weissenhof exhibition, who said similar things about women, when he separated reality from appearance?

Spinning, an operation we could see as that concerned with extracting order from chaos. From the shapeless mass of wool appears a structure, a dual structure. Weaving and warping. Let us return to Mies in 1928: "Chaos is always a sign of anarchy. Anarchy is always a movement without order. A movement without a clear direction. The order of ancient times was dispersed into the medieval age." He couldn't have expressed it better for us. To evoke Greece, from the spirit of time in Germany in the time of the Pavilion is to invoke this necessary order that had been lost. We still do not know under what auspices Mies invoked it.

Divine order, too. In Greek, *Kosmos* means order. Only the Gods order the sky, in their own way, of course. Here we need Plato again (*The Politician* 278 b/279 c). "What could we take, therefore, as a paradigm, what thing would be connected to the same operations as politics and which, even when still very small, was enough for us to find, by comparison what we are seeking? Would you like it, if we have nothing else at hand, for lack of anything grander, if we take the art of weaving?" The connotation of luxury goes with textile work. Hesiod explains this in the Theogony. A luxury is not only physical but intellectual. The carpet of the Pavilion and its red curtains are not only a necessary reunion of complement-ary(an) elements in order to re-present the myth and close it, but also the necessary manifestation of this overflowing luxury that the building exhibited. A pornographic image of a miserable Germany. "So that man may know himself better", said Seneca.

The luxury of the intellectual who aspires to be above the concept of time, diagnosing its catastrophe while at the same time being unable to avoid being fascinated by such a presumptuous action. Stuck in it. Condemned not to be able to intervene, only to take note of the inevitability of what happens. Reflection and shade, metaphors of the image, from Plato. The shade, that which the unconscious either shows or hides. Jung is clear when he says: "The unconscious contains the material that has not been able to reach the liminal threshold of the conscience." We are missing something, the statue by Kolbe, placed over the black water of the Pavilion. The only specific representation that the Pavilion exhibited. The woman, naked, the other.

**6** In 1924, Mario Sironi painted a picture called *The pupil*. We do not know if Kolbe had seen it, but the truth is that the German's sculpture is identical to the image of the naked woman at the bottom of the Italian artist's canvas. Sironi, who Jean Clair describes as tall, solitary and taciturn. Just as Döblin describes Franz Biberkopf. And also as we could imagine Mies. Aided by the images that Schulze and Hochman present us with, we can perceive his distant, lost stare. Melancholy? Describing *The pupil* Clair says: "A female figure in an architecture of colonnades, she seems to be leisurely, unconcerned, incapable of taking upon herself the power over the world which places within her reach the emblems of the liberal arts that are around her, the set square, the baluster, the sculpture." If the woman Sironi painted shows this incapacity that Clair explains, no less clear are the words of Mies in a note for a lecture: "The existing frontiers resulting from society's economic situation cannot be crossed." Mies, as melancholic as the metaphysical painters. In June 1930, when the Nazis began their unstoppable rise, he said: "The new era is a fact. It exists independently of our 'yes' or 'no'. It is neither better nor worse than others. It is a pure detail... We accept the economic and social changes as a fact... Everything takes its blind and dismal course."

We can also quote Clair: "The aesthetics of Metaphysics spread across the north part of the Alps, and with it the subject of melancholy was diffused." The paintings of Heise, Schrimpf, Scholz, Hoerle, or the selfsame Dix, painted between 1923 and 1930, abound in the topic and the name. Technical progress generated melancholy.

In the painting by Dix, *Melancholy*, painted two years after that mentioned at the beginning of this text, we are shown an interesting image. A naked woman violently shakes a mannequin, surely a reference to those represented by the Italian metaphysical painters, pushing it off herself. Her left hand points to a skull on the floor, while she announces an imminent masturbation. It could be the recollection of Weininger's writing. The naked woman, the symbol of reality, who does not need man to attain pleasure, is also the symbol of death, of the impossibility of conceiving, of the resolved negation of doing so: closing herself off from any type of relation is ensuring her own order, of which she is mistress. Tellebanch and Lambotte state that the structure of the melancholic type stems from an important formal principle: the principle of order. Order to avoid chaos. Mies wrote a disturbing image of his time: "Chaos is in all spheres, in the economic, social and intellectual."

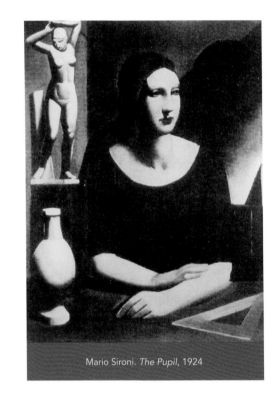

Mario Sironi. *The Pupil*, 1924

Kolbe's statue is protected from all the falseness surrounding it. Its reflection is sunk into the black water. The reflection dies, despite its permanence. The image of the woman dies, but her authentic presence survives. The only authentic part of the Pavilion. Mies always had interesting and in no way sentimental relationships with women. "Everybody has emotions and this is the hell of our time", he said in an interview quoted by Hochman. He lived depending on women, without getting involved, without loving them. They helped him climb the social ladder or paid his bills. Ada, Lilly. Perhaps with Lora it was different, although he never lived with her, and this is beyond the period that interests us, since they did not meet until 1940. Or surrounded by them: Marianne, Dorothea Waltraut, his daughters, feminine reflections. In the Middle Ages it was said of melancholy that: "Iste fugit meretricem". To despise loving relationships. Like Dix's woman, at the bottom of whose canvas we can make out a destructive, lethal and premonitory fire. Behind the statue by Kolbe, the green marble, the green death. Greece again.

7 The statue by Kolbe is called *Dawn*. It promises something. It awaits something. Protecting itself from its hostile environment of reflections, of illusion, it seems to want to ignore what it sees, waiting for better times. Athena also rejected the reflections. In the Greek world the mirror was used as an element for predicting the future. We only have to look at Aristophanes or Plato's Timeus to check it. Everything forces us to extend the presence of the Pavilion to the Germany that was to come. "Dreaming of staring into water is a sign of death." Long-reaching reflections. Hitler saw photographs of the Pavilion. Impassive reflections, in the form of presences that would gradually deny him any possibility,

presences as heavy as stones, that would fall on Mies. Blinding reflections, or perhaps an excess of vanity, that would not allow him to become aware of the reality that the Nazis were imposing. He would sign manifestos in favour of Hitler and accept placing swastikas and eagles in the German pavilion in Brussels in 1935. All in vain.

As Philip Johnson liked saying, throughout 1930, Mies had no other responsibility than that of his New York apartment on 24 West 52nd Street. On the 5th of August 1930 he was appointed director of the Bauhaus and entered the competition for the monument to the dead on the inside of the "Neue Wache" by Karl-Friedrich Schinkel. In 1931 he is head of the *Housing in our time* section in the "Bauausstellung" of Berlin and commissions projects to Luckhardt, Haring, Gropius, Hilberseimer and Lilly Reich. Mies designs a house for this exhibition, whose ground plan seems to be a revision of the pavilion of Barcelona. One has to concentrate not to confuse the two. The first reflection that follows him.

The following year was not much better either, since he only designs two small buildings, the house of the printer Karl Lemcke and that of the director of the German Academy in Rome, Herbert Gericke. In the July 1932 elections, the Nazis obtained 13,745,000 votes and 230 seats in the senate. Hitler demanded he be named Chancellor. Now things really began to heat up and the German air began to be, for some, unbreathable.

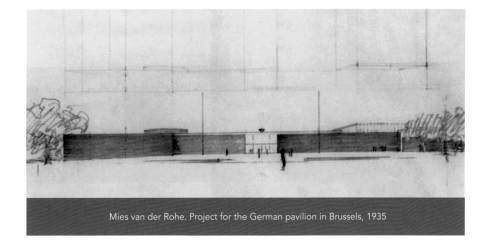
Mies van der Rohe. Project for the German pavilion in Brussels, 1935

On the 22nd of August the Dessau Council decided to close the Bauhaus, that "glass palace of oriental taste" or "the aquarium". Mies moved the school to Berlin and turned it into a private institution. Towards the end of the year, left-wing students accused Mies of giving in to fascist pressure and adapting to the demands of the Third Reich. Mies expelled them. In March 1933, when the Nazis won the majority in the Reichstag, some students from the Bauhaus unfurled an enormous swastika over the front of the school. From this moment on, the controversy enters into an important dialectical spiral. Some architects, such as Max Cetto, Wassily Luckhardt or Bruno Werner, tried to convince the Nazis that the architecture they needed was modern architecture. Mies also tried to do the same. Other brawls broke out. For example, that which featured Rosenberg, the architect heading the KFDK and Goebbels, appointed, in March 1933, as head of the Ministry of Propaganda.

The architects still had some hope left. When, in February 1933, the competition was held for the Reichsbank building, the Nazis invited Mies, Gropius, Poelzig and Tessenow. Did they have any chance? Mies decided to talk with Rosenberg, to try to find out if he was prepared to reopen the Bauhaus, what could be the future of modern architecture in Germany and to find out if there was room for modern ideas in the competition for the German bank. Rosenberg waited several days before receiving him and as the conversation evolved – Hochman has described the contents of it – Mies could only hear negative replies. On the 10th of May 1933, when the Nazis had already decimated the Prussian Academy of Art, of which Mies was a member, they burnt books in front of the facade. Before 40,000 spectators Goebbels said: "These flames are not only the end of the old era, they light up the new." The lights of Nazi art and architecture that were still to come had their origin in the reflections of a flame. Dix was not mistaken. Another reflection of falseness: the presence of Hans Weidemann, secretary of Goebbels or that of Otto Andreas-Schreiber, appointed as director of the Fine Arts section of the KFDK. Defenders of modern ideas tried to organise exhibitions or competitions.

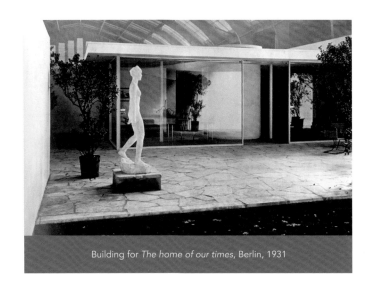

Building for *The home of our times*, Berlin, 1931

Weidemann, who asked Mies for photographs of the pavilion of Barcelona and who persuaded Walter Funk, Secretary of State in the Ministry Propaganda, a contact between the party and the German industrial barons and an admirer of Mies, to show them to Hitler. Hochman explains the result of the interview: "Hitler's reaction was hardly what Weidemann had hoped. Fortunately, for Funk, Hitler thought of him as a 'financial' not an 'artistic' man, and, not taking his artistic judgements seriously, was able to disregard his impudent gesture. Even so, he could hardly believe that Funk could be so insensitive as to suggest that the architect of the overssed factory building whose photographs lay before him could possibly be considered for affiliation with his regime...(and)...that this bastard temple to technology...was nothing more than a whorish mockery of the misguided worship of mass production. Declaring his opposition with such firmness that even a 'financial' man could understand, Hitler sternaly brushed aside the ofensive photographs". A mortified Funk hurried to inform Weidemann. "For the time being, Mies van der Rohe is dead as an architect in Germany". The Pavilion was the undoing of its creator. Its black water claimed more victims than Döblin prophesied. In January 1934, after Goebbels had forced him to remove expressionist paintings from his office walls, Weidemann resigned from his post.Mies' "death", however, was an agonisingly slow one. On the 21st of April 1934, the "Deutsches volk/Deutsche Arbeit" show was opened, in which Mies presented the pavilion of German Mining, with those shiny anthracite walls. Reflections achieved with poor materials. Speer explains that Hitler did not find that very funny either. Despite that, when in August 1934 the

Nazis approach some cultural figures to sign a manifesto supporting Hitler, Mies, who had been under criminal investigation since January, signed. It did not do him much good though and neither did his application to be admitted to the NS Volkswohlfart in August of the following year. Hitler wanted nothing to do with Mies' project for the German pavilion in Brussels. Rather, he wanted to know everything.

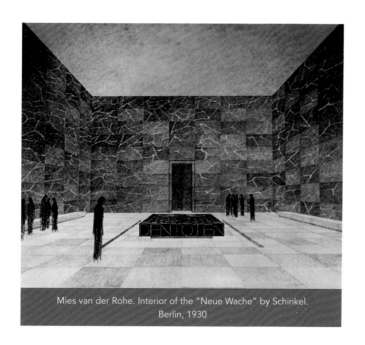
Mies van der Rohe. Interior of the "Neue Wache" by Schinkel. Berlin, 1930

He had all the models and plans sent to his office at the Chancellery. Sergius Ruegenberg, a young assistant to Mies, describes the lamentable spectacle of the models' remains and torn drawings, lying broken on the floor. He recounted this to Hochman in a very graphic way, while the latter was preparing his text: "Hitler took the decision with his feet." There would be no German pavilion in Brussels.

Despite everything, plus the fact that from 1935 he began to have offers from American universities, Mies did not want to leave Berlin. Just like Franz Biberkopf, Mies checked, day by day, that time and the German capital were destroying him. He thought that leaving would be an act of cowardice. He resisted in his impassive sorrow. As if what was happening to him had nothing to do with him. Melancholy. He still held the last bullet, until it exploded in his hands. Hermann Göring forced him to abandon the project and ordered him to hand over the plans for the German Textile Show to Ernst Sgabiel, a mediocre associate of Mendelsohn, who built something that horrified Mies. Once again, the construction of a pavilion showed him some realities that he did not want to see. Now there was no possibility of finding refuge in comforting reflections. This time things were too clear. This was the end. It was the 24th of March 1937. In the last scene of *Cabaret*, Fosse shows us a still swastika through the reflections. On seeing the reconstruction of the Pavilion, this image is the first thing that comes to our mind.

**8** It has been Carlo Ginzburg who has alerted us to the repeated political use of mythology which specific systems have undertaken. He quotes Nietzsche to explain it: "The State knows no laws or deeds that are more powerful than mythical thought." Ginzburg continues: "The use of myth as a lie hides something that is deeper. The legitimisation of power returns us necessarily to an exemplar history, to a beginning, to a founding myth." The pavilion has forced us to pass by among myths. Everything in them is wisdom. The strange is excluded. Mies tried, in 1927 and 1929, to allude to some surprises with which modern thought questioned the Germany of the inter-war years. He tried, let us say. He wanted the myth to provide him with the beginning from which he could open up questions about what

kind of architecture to build. He kidded himself that he did not know the outcome. He failed. Myths are tough-skinned, said Nietzsche, and before breaking a myth you will break your leg. Kolbe's statue did not want to play the game and announced the dawning of other realities. Its naked presence shows that truth that Mies refused to see until 1937. He was the last to leave. Franz Biberkopf must have come to bid him farewell.

Hitler also postulated with the myth, but with a different tone. With a repugnant immediacy and literalness. Safe architecture, which presented a known past from which to dominate the world. He played with marked cards, hand in hand with Speer and Troost, gathering what they had said. Safe was an architecture that placed Greece before the eyes of the German media. Greece, the natural origin of Germany, the Nazis said. Speer for example: "Our dreams draw us to the world of the Greek past." And Hitler: "Never has humanity been as close to the Greeks as it is today..." They organised the 1936 Olympic games. The black athletes spoilt the party and showed up some inferior aspects of the Aryan race. A premonition, we might say.

Gorgoneion

Meanwhile, unmoved, Hitler considered the Doric style as absolutely essential for a building that would represent his party. The rebirth of Greece was in his hands, as if what was involved was to recast the world, eliminating everyone that was superfluous in this process. Trying to invent a world without history. Kolbe's statue, which Mies chose for the Pavilion of 1929, announced too many catastrophes. In reality, they had already been foretold between its conception and choice, in some texts that were published in that turbulent Germany that had made the representative building at the International Exhibition of Barcelona a possibility.

In the words of Thomas Mann, written in 1925: "It is not the liberation and expansion of the ego that constitutes the secret of this time. What it needs, what it demands, what it will have, is terror." In the text by Döblin, in 1929, he writes: "Blood must flow, blood must flow, rivers of blood must flow."

We will end with Mies, who does not seem to be left behind: "That which in another time was the highest expression of life is slowly dying due to the banality of a task without sense, unless a strong, grandiose and bloodthirsty generation is not found first, in order to give a new expression to the changed vital contents." Mies crossed out the words "bloodthirsty generation".

Josep M. Rovira

published by: © Triangle Postals, S.L. 2011

with the colaboration of: Fundació Mies van der Rohe, Barcelona

photographs: © Lluís Casals

© Mies van der Rohe, Otto Dix, Mario Sironi, VEGAP, Barcelona, 2002

text: © Josep M. Rovira

translation: Steve Cedar

archive photographs: p. 5, Fundació Mies van der Rohe, Barcelona

p. 50, Art Institute of Chicago

p. 51, Berlinische Galerie

p. 54, ETSAB Barcelona

p. 55, private collection, Barcelona

p. 56, 57, 62, Städtische Kunsthalle, Mannheim

p. 58, 59, 60, 70, The Museum of Modern Art, Mies van der Rohe Archive, N.Y.

p. 68, private collection, Max Protetch Gallery, New York

design: Joan Barjau

printed by: Índice S.L.

colour separations: Tecnoart

depósito legal: B–29.112-2011

ISBN: 978–84–8478–039–7

printed in Barcelona

TRIANGLE ▼ POSTALS

www.triangle.cat